The Renaissance

ART IN DETAIL

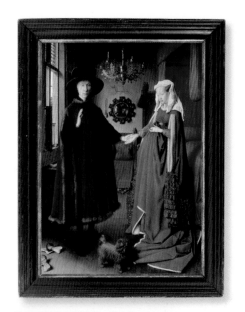

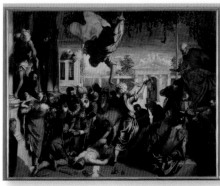

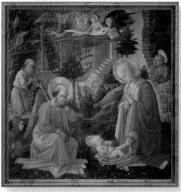

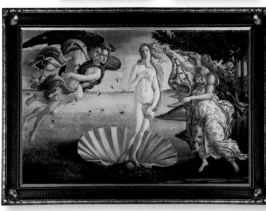

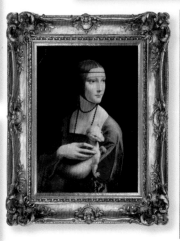

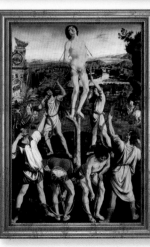

The Renaissance

ART **IN** DETAIL

Jeannie Labno

METRO BOOKS
NEW YORK

This book was conceived,
designed and produced by
Ivy Press
The Old Candlemakers
West Street, Lewes,
East Sussex BN7 2NZ, U.K.

Creative Director Peter Bridgewater
Publisher Jason Hook
Editorial Director Caroline Earle
Art Director Clare Harris
Senior Project Editor James Thomas
Designer Jon Raimes
Concept Design Alan Osbahr
Picture Research Katie Greenwood

Metro Books
122 Fifth Avenue
New York, NY 10011

ISBN-13: 978-1-4351-0376-4
ISBN-10: 1-4351-0376-9

Printed and bound in China

10 9 8 7 6 5 4 3 2 1

Picture Credits
The publisher would like to thank the following for their
permission to reproduce the images in this book. Every
effort has been made to acknowledge the images, however
we apologize if there are any unintentional omissions.

AKG Images/Erich Lessing: 44–49. **Bridgeman Art
Library**/National Gallery, London: 25R. **Corbis**/©
National Gallery Collection; By kind permission of
the Trustees of the National Gallery, London: 50–55.
Scala, Florence: 8–13, 14–19, 62–67, 74–79, 92–97,
98–103, 104–109; By permission of Curia Patriarcale di
Venezia-Ufficio Beni Culturali: 80–85; By permission of
the Istituzione Biblioteca Museo Archivi di Sansepolcro:
38–43; Courtesy of the Ministero Beni e Att. Culturali:
32–37, 86–91, 110–115, 116–121, 122–127.

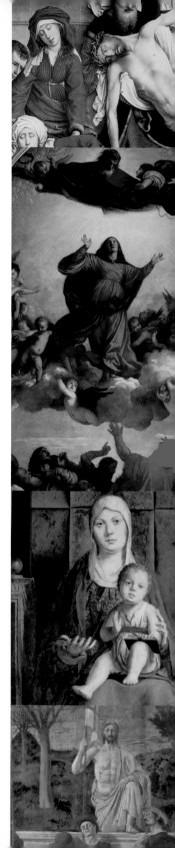

Contents

Introduction

ALTHOUGH THE RENAISSANCE IS REGARDED as the period of rebirth of classical antiquity, in fact antiquity had never disappeared, but survived throughout the Middle Ages. Instead, antiquity was re-discovered, in that it was regarded in a new light—the Renaissance movement heralded a fundamental change of attitude toward antiquity. A key issue was the problem of compatibility of the Christian and the pagan. In medieval art, classical motifs were used for Christian themes, while classical themes were presented in contemporary medieval forms. The union between classical form and classical subject-matter did not occur until the Renaissance, when antique subject-matter was re-integrated with antique forms. However, this reintegration of classical themes and classical motifs was not a simple reversion to the classical past. Tastes had changed and consequently new forms of expression were required, which were stylistically and iconographically different from both the classical and the medieval, yet related and indebted to both. This then is the true meaning and function of Renaissance art.

It is generally agreed that the Renaissance began with Giotto—not because his work demonstrates a revival of ideal classical form, which first appears in the work of Masaccio, but because it demonstrates a new sense of the relationship between God and humanity. Thus it is appropriate that this selection begins with Giotto's greatest work in the Arena chapel.

The two centuries beginning with the work of Masaccio were a period of tremendous innovation and collaboration, of the long process of trial and error,

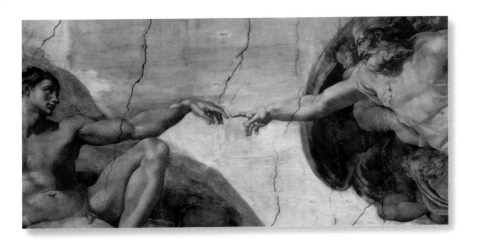

in which aims, ideas and techniques were passed down from master to pupil—
and occasionally even pupil to master, as in the case of Giorgione and Bellini.
Artists learned from each other. Sometimes this resulted in what we regard as a
"work of genius." Such innovation was fuelled by rivalry and competition, and
by the desire to *exceed*. Just think, Michelangelo and Raphael were working—
separately—in the same building, the Vatican, for the same patron, for several
years. It was an exciting and stimulating period taking place within a time of
important socio-political change. Such art does not take place within a vacuum
but belongs to its context.

To select just 20 paintings from this great period of artistic change and
development seems simplistic—how can we reduce the 200 years of Renaissance
art to just 20 works? How to choose just one work that is representative from
the immensely long lives of artists like Bellini or Titian, who both encompassed
different styles and genres? Well, of course, we can't. This is a personal selection;
it certainly is not a Top Twenty! Nor, despite their chronological ordering,
should these paintings be regarded as a linear progression. They are each
significant, either in their own right or as an important work of a significant
artist, representing a particular style or development. They are not definitive.
Hopefully they will encourage the reader to explore further this fascinating
and rewarding period of artistic development, which is so important a part of
Western culture and its presuppositions. By engaging with Renaissance art, we
learn to engage with art of our own culture—the one informs the other.

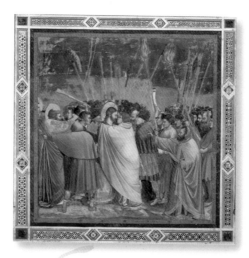

GIOTTO DI BONDONE, c.1267–1337

The Kiss of Judas, or The Taking of Christ
1304–13, fresco, Arena Chapel, Padua, Italy

GIOTTO DI BONDONE IS WIDELY ACCLAIMED as the founder of modern Western painting due to the major contribution he made to the "artistic revival" that marked the beginnings of Renaissance art. By means of interpretive illustration he was able to convey the human condition by relating human motivation, human emotion, and visual forms of human expression. His naturalistic skills and ability to draw in and engage the imagination of the viewer, thereby enabling the viewer to identify with the drama depicted, established his reputation and earned him the accolades of artists such as Leonardo da Vinci, Ghiberti, and Vasari, as well as the writers Dante and Boccaccio. Giotto influenced the generation of painters that proceeded him, but it took a hundred years—and the skills of Masaccio in the Brancacci Chapel—before the next significant development in artistic techniques arose.

c.1280–1300	1301	1304–13
Giotto studies and works in Rome	Giotto lives in Florence	Set of six choir-books begun for Padua Cathedral, containing copies from some Arena Chapel scenes

The basis of Giotto's extraordinary reputation lies in one of the most remarkable artistic schemes in the history of art—the decoration of the Arena Chapel in Padua, in particular, the 36 narrative scenes arranged in three registers around the side walls. The work was commissioned by Enrico Scrovegni, a wealthy Paduan merchant, around 1305. The chapel was primarily designed for family worship and as a memorial for Enrico. Aptly, it was dedicated to the Virgin of Charity and the overall theme was salvation. The narrative cycle begins at the top of the south wall near the chancel and ends at the bottom of the north wall near the chancel. It covers the life of Joachim and Anne, the parents of the Virgin; the life of the Virgin; and the life of Christ, ending with the Resurrection and the Feast of Pentecost.

Much of the originality of Giotto's work can be credited to his skill for artistic realism, so clearly demonstrated in this cycle of paintings. There is a convincing correspondence between his images and the world as we see it. He portrays familiar poses, gestures, and expressions, while his fully modeled figures occupy coherent, illusionistic space. He achieves an overall spatial integration of this vast, unarticulated space, as represented by the walls of the Arena Chapel, through a range of fairly complex compositional and technical devices.

Fact

Enrico's father had been a notorious usurer, which was a mortal sin in the eyes of the Church. The construction and endowment of the Arena Chapel could be seen as an expiation for this activity.

72 in (183 cm)

78 in (198 cm)

1334	1350	1450	1880
Giotto returns to Florence and is appointed chief of works of Florence Cathedral	In Boccaccio's *Decameron* Giotto is described as imitating nature well enough to deceive	Ghiberti records that Giotto had decorated four chapels in Santa Croce: only Bardi and Peruzzi survive	After a long campaign, the arena chapel becomes public property

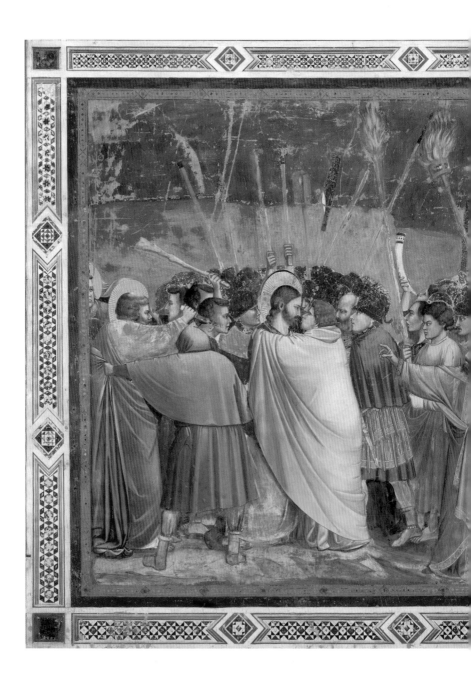

The *Kiss of Judas* occupies a key position—in the middle of the lower register of the south wall of the chapel. It represents a turning point in the narrative, and initiates the scenes of Christ's suffering, which ends in the Crucifixion. It is at this point that the lateral narrative stops—is, indeed, arrested (as is Christ). The central figures of Christ and Judas are locked together in the quiet epicenter of the dramatic events that surround them, in that moment before the consummation of the kiss—that psychological moment when their eyes meet, when Judas hesitates and Christ's prescience of his fate is clearly evident in his gaze. Here we have the humanistic depiction of Christ's humanity and the relationship between God and human, which was characteristic of the Renaissance viewpoint.

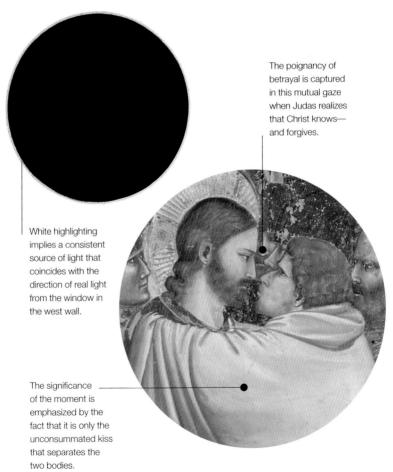

The poignancy of betrayal is captured in this mutual gaze when Judas realizes that Christ knows—and forgives.

White highlighting implies a consistent source of light that coincides with the direction of real light from the window in the west wall.

The significance of the moment is emphasized by the fact that it is only the unconsummated kiss that separates the two bodies.

The pale yellow mass of Judas' cloak focuses attention on the two main figures and fixes them in the center of the field of view. Note how it continues into the pale gold of Christ's halo, seeming to envelop and entrap him.

Flesh tones were achieved by applying layers of pink to a base layer of *terra verde*. White highlights were used to emphasize the parts of faces or hands that were illuminated by light.

Gilding on haloes was applied *a secco* and was therefore, vulnerable to loss by fading and flaking.

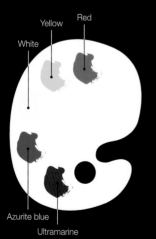

White

Yellow

Red

Azurite blue

Ultramarine

Giotto uses different coloristic effects to enhance the spatial unity of the overall scheme. For example, the deep blue background serves to integrate the individual scenes within the same illusionistic world and provides a naturalistic impression of space and depth. Decorative unity is further enhanced by employing an even range of coloring throughout and by a consistent color scheme, such that the main protagonists are color-coded—Judas, for example, can be identified by his yellow cloak. Highlighting is used to evoke a consistent source of light, thereby reinforcing unity, and to model the figures so that they appear solid and rounded. Saturated colors are used for shadowing and *en bloc* to emphasize important figures, such as Christ.

Fresco painting, where pigment was applied to a fine layer of wet plaster known as *intonaco*, was a relatively new technique at this time. The colors bonded with the *intonaco* to provide a hard, waterproof surface. Sufficient *intonaco* was applied for each day's work (*giornata*). Attempts were made to mask the joins between *giornate* by using lines or changes of color, but they are still visible in the Arena Chapel. *Giornate* varied in size according to complexity— so areas of sky might be large, while areas for faces or hands would be smaller. Minor corrections and details were made on the dry surface *a secco*, which was also used for deeper colors and denser pigments, as well as for white highlights. Unfortunately, colors applied *a secco* were less stable and tended to flake off.

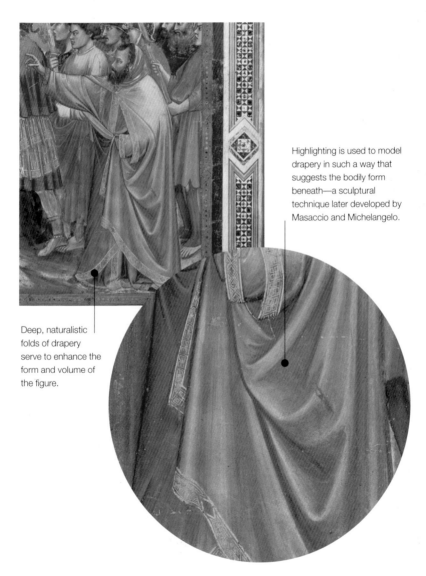

Highlighting is used to model drapery in such a way that suggests the bodily form beneath—a sculptural technique later developed by Masaccio and Michelangelo.

Deep, naturalistic folds of drapery serve to enhance the form and volume of the figure.

MASACCIO, c.1401–28

The Trinity, the Virgin, and St. John with Donors and Sarcophagus

c.1427, fresco, S. Maria Novella, Florence

THIS PAINTING, UNIQUE IN THE HISTORY OF ART, was executed by the first, and the greatest, of the Great Masters of 15th-century Florence. It is the first painting to use the new rules of linear perspective, as developed by the architect Filippo Brunelleschi (1377–1446), which revolutionized art and remained the dominant convention of Western painting for the next 450 years, until the time of the Cubists. The dating is uncertain, but it is thought to have been painted after the decoration of the Brancacci Chapel in 1427 but before Masaccio's departure for Rome in 1428, where he died aged 27.

1418	1422	1510
At age 16, Masaccio referred to as a painter in Florence	Masaccio becomes a member of the Florentine painters' guild, Arte de' Medici	*The Trinity* first recorded by Francesco Albertini in *Memoriale di molte statue e picture di Florentia*

Masaccio's debt to Giotto is evident in the sculptural monumentality of his figures but other influences, including Donatello, are also evident. The end result, however, is distinctly Masaccio. A hundred years later artists were organizing competitions for the best copies of his Brancacci Chapel frescoes—the Trinity, however, was never replicated in paint, though it did inspire the construction of a chapel 25 years later in Pescia by Brunelleschi's adopted son, Buggiano.

It was painted in the third bay of the left aisle in the Dominican church of S. Maria Novella in Florence, but during remodeling of the church in the second half of the 16th century it was covered over. Thus one of the most extraordinary works in the history of art lay hidden for over 300 years. Unfortunately, large parts of the lower section were destroyed when the 16th-century altar was removed, but they have now been fabricated by a modern restorer.

In *The Trinity*, Masaccio updated the medieval Christian symbolism of resurrection and redemption and gave it Renaissance form by applying a more modern and scientific interpretation. Thus the harmony of the universe, in which humankind and God are inextricably linked, is reflected through mathematical harmony.

The Mystery of the Trinity is made real by situating the figures within the illusionistic space of a recessed chapel.

252 in (640 cm)

Fact

Apart from the precise, single vanishing-point perspective, there are numerous geometrical and proportional relationships: for example, the lower grisaille section is one-quarter of the whole; the top of the sarcophagus, on which God stands, bisects the height of the fresco; the upright of the cross bisects the rectangle formed by the two columns and the arms of the cross, and so on.

125 in (318 cm)

1570	1861	1950	1952
Fresco covered by a stone altar and a panel painting by Vasari	*The Trinity* is detached and moved to the internal façade next to the entrance, where it is reattached	*The Trinity* is thoroughly restored by Lionetto Tintori	*The Trinity* is moved back to its original location and reunited with the lower *grisaille* section

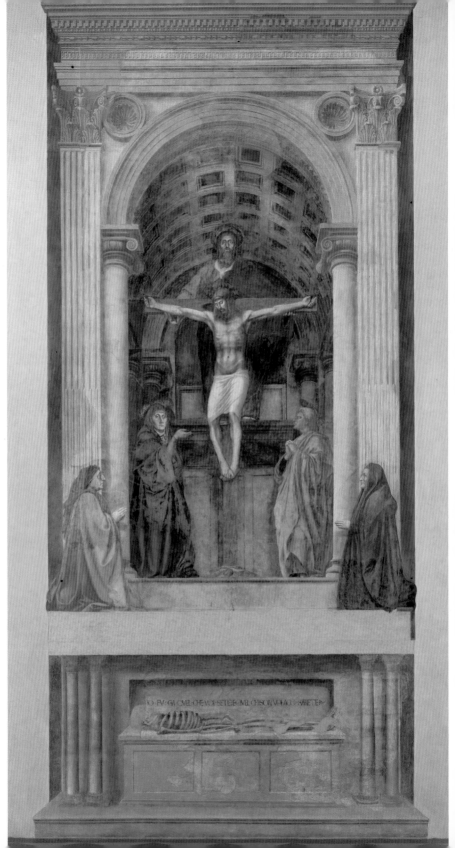

The Trinity is visually represented by merging together the face of God with the dove and the head of Christ.

Unlike most representations of the Virgin as youthful, Masaccio has chosen to portray her as a mature woman.

Although the piece is painted on a flat surface, Masaccio's illusionistic skill creates the impression of a recessed chapel, which lies beyond the surface of the wall. The figures are placed in a pyramidal composition within realistic Renaissance architecture. A coffered barrel vault is supported by Ionic capitals, flanked by Corinthian pilasters surmounted by a classical entablature to form a triumphal arch. In the bottom section, a skeleton lies on a sarcophagus with an inscription, in Italian, which reads: "That which I am you will also become." Above, the donors occupy the threshold between the real world, where the viewer stands, and the spiritual world depicted beyond. Looking slightly upward we see the foreshortened figures of St. John and Mary, who direct our gaze to Mary's Son. At the apex of the triangular composition, framed by the triumphal arch, is the Holy Trinity. We look directly at God, without foreshortening.

Unlike Giotto, who used a greenish base layer for flesh tones, Masaccio has used gray tones for his underpainting. ———

Note the use of black and red in the coffered vault and how elsewhere these colors range in tonality with grays and warm sandstone.

When this work was originally painted, there were two sources of natural daylight: a round window in the façade and the entrance from Via degli Avelli, now blocked, which Masaccio used as the basis of his light effects. He was the prime exponent of *rilievo*, the appearance of a form modeled in the round by the skillful treatment of tones. It is through the careful manipulation of the degrees of light and shade that we perceive the form of figures and objects. It is this treatment that creates the appearance of volume and solidity, not only to the human and divine bodies but also to the massive architectural detail.

Masaccio's palette is very restrictive and repetitive. He often limits his colors to just two or three—for example, red, blue and sometimes black and/or orange-yellow—and then exploits their chromatic range by subtle changes in tone.

Red
Black
White

Lay a ruler along the edges of any line of coffers and the inside edge at the top of the capitals and they will meet at the foot of the cross.

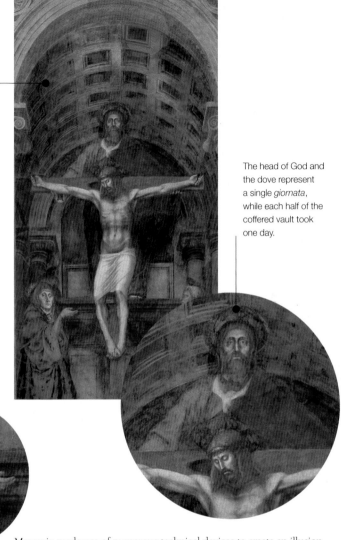

The head of God and the dove represent a single *giornata*, while each half of the coffered vault took one day.

Traces of Masaccio's working methodology are evident, which indicate new procedures. Unprecedented is the grid excised in the plaster around the Virgin's head, which enabled him to render accurately the complex three-quarter view as seen from below.

Masaccio made use of numerous technical devices to create an illusion of reality. The revolutionary nature of his precise one-point perspective required meticulous planning. In perspective, the parallel lines receding from the plane of the picture surface appear to meet at a single "vanishing point." Systematic perspective allows for systematic proportion. Masaccio used these principles to create a geometrically controlled, illusionistic space inhabited by realistic figures within a convincing architectural setting. The point where all the orthogonals meet is at the foot of the cross, at about the head-height of the viewer. Thus we look down at the skeleton but up at St. John and Mary, who are foreshortened. There are 28 *giornate*—so, even with additional *secco* work, it probably would have taken less than two months to complete.

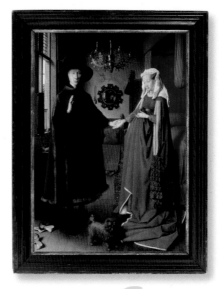

JAN VAN EYCK, d.1441

The Portrait of Giovanni Arnolfini and his Wife Giovanna Cenami, or The Arnolfini Marriage

1434, oil on oak, National Gallery, London

THIS FAMOUS AND CONTROVERSIAL PAINTING was executed by Jan van Eyck in 1434 and, in its own way, was as new and revolutionary as Masaccio's work, albeit for different reasons. Although much has been written about this painting, opinions vary and, in fact, we do not know for certain the identity of the people represented or the purpose of the work. It would appear to depict a married couple and is thought to be Giovanni di Nicolao Arnolfini and Giovanna Cenami, perhaps on the occasion of their marriage or betrothal. This theory is predicated on Giovanni remarrying between the death of his wife in 1433

1422	1423	1425
Van Eyck is first documented as an established artist, working for Count John of Holland	Appointed court painter to Count John of Holland	Appointed court painter and *valet de chambre* to Philip the Good, Duke of Burgundy

and the painting of this double portrait in 1434—not impossible, but not proven either. Recent opinion holds that it does not represent their marriage, although its real meaning remains obscure.

Mystery and myth also surround Jan van Eyck. We do not know where or when he was born and, although there are many works dated and signed by him, we know little or nothing about him before 1422. We do know that he completed the celebrated Ghent altarpiece in 1432, which is thought to have been started by his brother Hubert, who died in 1426. This is the same decade that the great works of Masaccio and Donatello were completed. Unlike the Florentines, who applied the rules of perspective and foreshortening and created their figures from a profound understanding of anatomy in order to achieve realistic representation, van Eyck did not effectively engage with these scientific theories of optics. Instead he adopted a different approach, achieving the illusion of nature by close observation and the analysis of surface textures and minute details. In this way he was able to reach an understanding of form and space. His particular style and methodology were enhanced by his development of the techniques of oil painting and varnishes.

Van Eyck's slow, meticulous approach resulted in works of startling realism, which, however, lacked somewhat in drama or emotion; unlike, for example, the work of Rogier van der Weyden. Perhaps as a result of this, despite universal acclaim and recognition, his influence later declined and was eclipsed by van der Weyden.

32 in (82 cm)

Fact

Jan van Eyck is often credited with the invention of oil painting. This is not true, although he certainly perfected the technique that enabled his brilliant colors to survive almost unchanged.

—24 in (60 cm)—

1430	1432	1433	1434
Moves to Bruges, where he lives until his death	Completes Ghent altarpiece and paints *Tymotheos*, inscribed *Leal Souvenir* ("loyal remembrance")	Paints *Man in a Red Turban*, which may be a self portrait	Paints *The Arnolfini Marriage* and signs the painting with "Van Eyck was here"

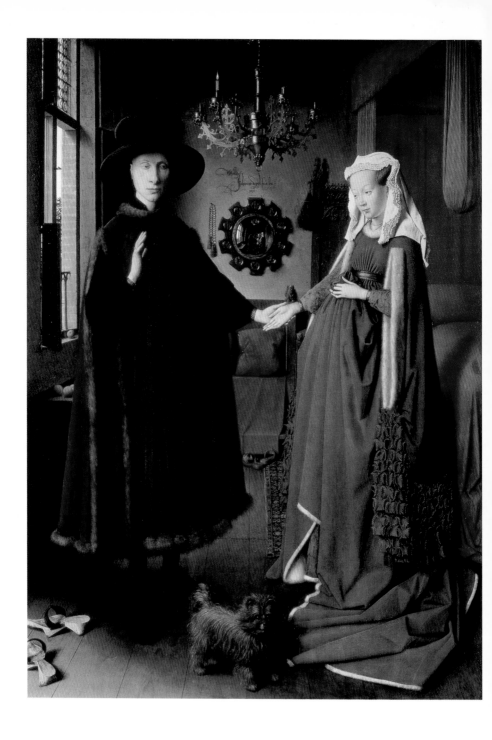

The lighted candle, although it is daytime, has been taken to represent the presence of Christ, but also indicates the transience of human life.

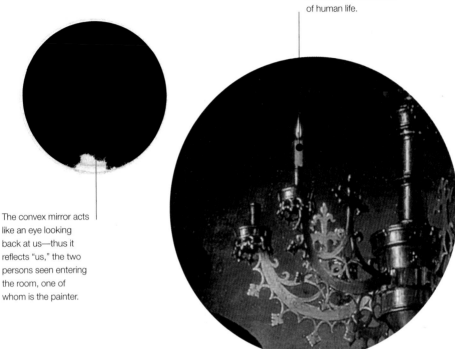

The convex mirror acts like an eye looking back at us—thus it reflects "us," the two persons seen entering the room, one of whom is the painter.

This enigmatic painting fascinates not only because of its meticulous realistic detail but because of its intriguing iconographic content, such as would have been readily accessible to the contemporary viewer, but much of which we are now unable to decode. We observe a wealthy couple, whose figures loom large in the foreground of a restricted and confined space. Despite this, the artist has managed to cram in a very impressive range of objects and symbols. The woman's figure is particularly "opulent," and although she appears to be pregnant, it is now thought that she is merely fashionably dressed. Between the couple are a convex mirror on the rear wall and a brass candelabrum on the ceiling above, while on the floor between them is a dog, a symbol of marital fidelity.

Light and shade are used expertly here to indicate the detailing of lace and the complex fall of drapery, which acts like an aureole to illuminate the woman's face.

Color and tonal contrasts serve to differentiate spatial relationships, enhanced by the use of light, which indicates space by varying intensity and creating cast shadows The medium of oil allows smooth transitions of chromatic shading, while transparent layers or "glazes" enable glittering highlights on the candelabrum, the rosary beads, and the mirror.

The burnished glow of her belt and the glitter of gold on belt and cuff were achieved by layers of tinted glazes.

Black Red
Blue Green

Lead white

The figures are flanked on the one side by windows, which are one source of light, and on the other by the sumptuous marriage bed. Thus the man's dark clothing is contrasted with the light streaming through the window, while the woman's deep green dress is contrasted with the rich red of the bed hangings. Brilliant colors are combined for stunning visual effect: the almost iridescent blue of her sleeve, the lush green of her robe edged with creamy fur, and the rich range of reds. Small amounts of lead white are also added, particularly on flesh areas, to increase reflection.

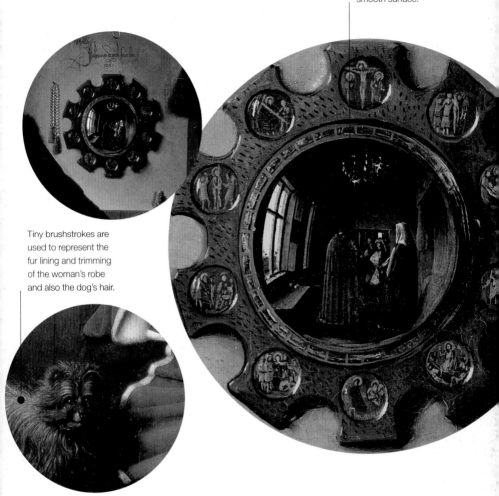

The fluid quality of oil permits a technique of "invisible" brushstrokes that create a perfectly smooth surface.

Tiny brushstrokes are used to represent the fur lining and trimming of the woman's robe and also the dog's hair.

Artists had to make up their own pigments using colors from plants or minerals, which were ground up and mixed with a liquid to form a paste. The usual binding "liquid" used was egg (tempera) but the disadvantage was that it dried quickly, which largely precluded retouching or repainting. Using oil instead of egg allowed van Eyck to work more slowly and accurately because it took longer to dry. Tinted glazes of oil could then be applied in layers over the underpainting, which reflected light at different intensities producing glowing and glittering effects. The first main color might be in a middle tone with multiple layers of lighter and darker glazes to allow modeling and volume. On completion, the whole painting would be varnished for protection.

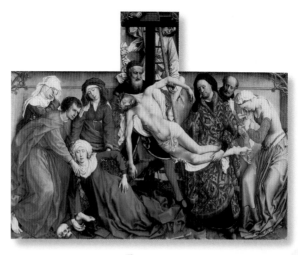

ROGIER VAN DER WEYDEN, c.1399/1400–64

Descent from the Cross, or Escorial Deposition
c. before 1443, oil on panel, Prado, Madrid

ALTHOUGH LITTLE IS KNOWN FOR CERTAIN about Rogier van der Weyden—also known as Roger of Tournai, Roger of Louvain (Leuven), and Roger of Bruges— he was one of the most profound and influential artists of the 15th century. There are no signed and dated works by him, but three surviving paintings have been securely authenticated: *Descent from the Cross* (before 1443), the *Moraflores Triptych* (before 1445), and *The Crucifixion* (after 1454). It is against these that all other attributions are made—especially the *Descent*, which is one of the greatest masterpieces of Northern European 15th-century painting.

Like Jan van Eyck, Rogier achieved a competence and mastery of oil paints that made him celebrated throughout Europe. They both suggested realities by exploiting the medium's unique capacity to depict the visual effect of light on

1427	1432	1435–40
Rogier enrols as an apprentice in the workshop of Robert Campin	Becomes independent master of the guild of painters	Probable dates for completion of the *Descent from the Cross*

various surfaces. Unlike the dispassionate realism of van Eyck, Rogier developed a more emotional, dramatic style that demonstrated a sensitivity and sympathy with divine suffering and the human condition, which ultimately proved more influential to the next generation of artists. He created a range of new forms and compositions that were copied throughout the Netherlands, Spain, and Italy until the mid-16th century.

Rogier is thought to be the Rogelet de la Pasture who in 1427 was apprenticed to Robert Campin (generally acknowledged to be the Master of Flémalle). In the same year he married and by 1436 was appointed town painter of Brussels, where he lived until his death in 1464. In 1450 he visited Rome and Florence, where he painted *The Entombment* (now in the Uffizi, Florence), which shows strong Florentine influence, especially that of Fra Angelica. At the same time, he may have tutored Italian masters in painting with oils.

Rogier tended to eschew accurate representation and spatial logic in favor of dramatic and powerful imagery achieved through exaggeration and even distortion. The effect is disturbing, creating a sense of unease that plays on the viewer's emotions. The best example of this is the *Descent*. It was painted for the guild of crossbowmen of Louvain, as evidenced by the small crossbows contained within the tracery at the corners.

Fact

By the end of the 16th century, confusion over his different names led the biographer Carel van Mander to identify Rogier as two different painters. His work and name were forgotten until the mid-19th century. Since then a slow and meticulous re-evaluation has restored his pre-eminence as one of the most important artists of the 15th century.

86 in (220 cm)

102 in (260 cm)

1443	1450	1549	1574
Earliest copy of *Descent from the Cross*, which forms center of the *Edelheer Triptych* in Leuven	Bartolomeo Facio, the Italian humanist writer, records that Rogier visited Rome in 1450	The painting is first recorded in the collection of Mary of Hungary, who later gave it to her nephew, Philip II of Spain	Philip gives the painting to the Escorial, along with the *Crucifixion*

Rogier took a familiar subject, the deposition, and gave it a new interpretation with an innovative composition. He broke with the trend for realistic spatial depiction and instead crammed his 10 figures into a contrived and artificial space, which is thus subordinated to the drama of the figures and their intense emotional experience. Nine of the figures are set in an elliptical composition, arranged across the surface of the picture, somewhat like figures in a frieze. They are linked by flowing

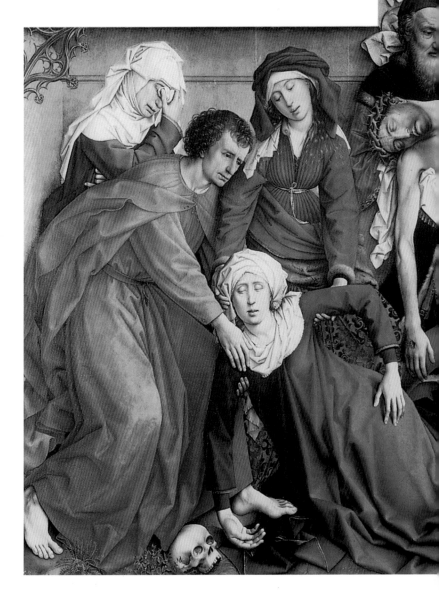

lines formed by the outlines of limbs and drapery and, at either
end, by the curved backs of Mary Magdalen and St. John. The
collapsed body of the Virgin mirrors that of her dead Son—their
hands seem to be about to touch, emphasizing that this scene
is but a moment in time, like a snapshot captured forever. Only
the skull and bones indicate the historical location—the hill of
Golgotha, the place of skulls and the traditional burial place of
Adam, whose original sin has now been redeemed.

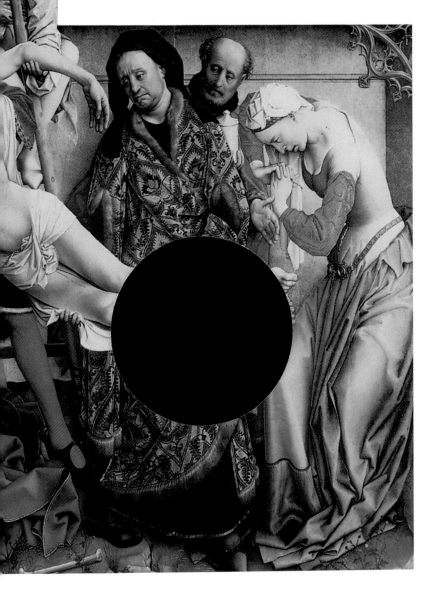

Rogier used the same limited range of colors as his Netherlandish contemporaries, albeit less intensively. As such, his colors are less translucent and jewel-like than, for example, those used by Jan van Eyck.

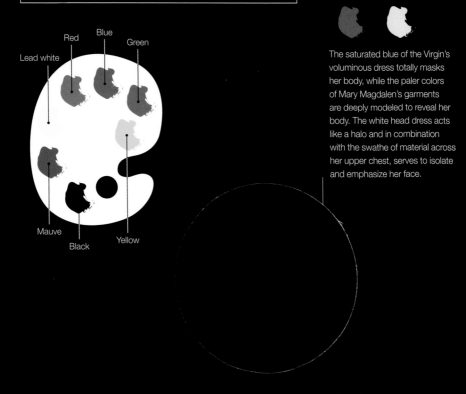

Lead white

Red

Blue

Green

Mauve

Black

Yellow

The saturated blue of the Virgin's voluminous dress totally masks her body, while the paler colors of Mary Magdalen's garments are deeply modeled to reveal her body. The white head dress acts like a halo and in combination with the swathe of material across her upper chest, serves to isolate and emphasize her face.

The composition is lit by a bright, diffuse light, like a stage set. This is reinforced by the gold background, which "pushes" the figures forward. Within the swirling, brilliantly colored clothing, Christ's pale, softly modeled body radiates light, while the glistening trail of blood trickles around the curve of his abdomen and inner thigh, emphasizing its sensual vulnerability. The arms holding him (Joseph of Arimathea) are clothed in red and Joseph's bright red left leg implies gushing blood. The darkness of his robe enhances Christ's pallidity, while the gold hem sweeping under Christ's body forms a link to the arm of the next figure, Nicodemus.

Clearly this work does not obey the laws of spatial recession and proportion. The cross, for example, is much too small to have supported the body of Christ. Moreover, Rogier disregards spatial logic and instead employs abstract means, exaggerated poses, and even distortion to increase unease and work upon the emotions. For example, the spatial relationship between the figures of the Virgin and St. John are inconsistent: his left leg is in front of her while his left shoulder is behind her—far too awkward a pose for him to sustain, let alone to help lift her. It soon becomes apparent to the viewer that the figures, in fact, could not realistically occupy the space available.

There is an "extra" hand thrust below and just in front of Mary Magdalen's clasped hands, which on first sight appears to belong to Nicodemus until you realize that his left hand is holding Christ's legs. Nominally it must belong to the figure behind but the articulation is illogical—visually this is disturbing.

Spatial inconsistencies, which may not be immediately apparent, result in instability in the composition, which disturbs the viewer. Joseph appears to be stepping into space but in fact his left foot is on the ground, only it is not the same ground level occupied by the others.

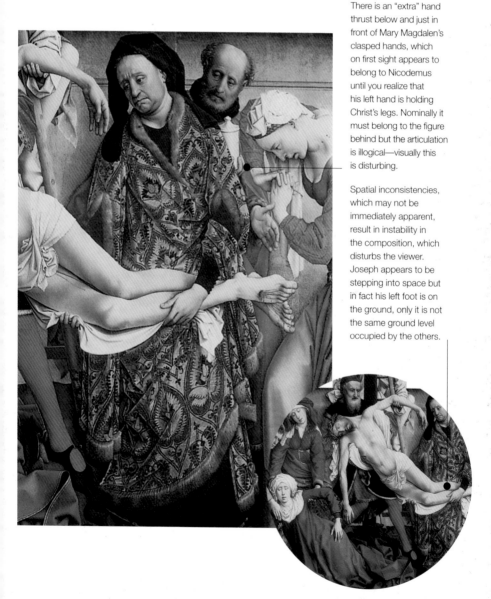

The Holy Family with Saints Mary Magdalen, Jerome, and Hilarion

c.1455, tempera on wood, Uffizi, Florence

FRA FILIPPO LIPPI WAS ONE OF THE LEADING PAINTERS in Renaissance Florence, following immediately after Masaccio, whose only direct pupil he is thought to have been. In 1421, aged around 15, he entered the Carmelite monastery in Florence where, in the 1420s, Masaccio was engaged in painting the Brancacci Chapel. By 1430 Lippi was documented as being a painter, and fragments of his frescoes at the monastery show the clear influence of Masaccio. His succeeding works show a gradual trend away from Masaccio toward Donatello and, by the mid-1440s, the influence of Fra Angelico's lyrical, more decorative

1421	1430	1437
Takes his vows at the Carmelite Monastery of S. Maria del Carmine in Florence	First referred to as a painter in the accounts of S. Maria del Carmine	Paints the *Tarquinia Virgin and Child*, indicating how Masaccio's influence gave way to Donatello's

style becomes apparent. His mature works show evidence of Netherlandish painters, such as Jan van Eyck and Rogier van der Weyden. Ultimately his work heralds the transition to a more graceful style, characteristic of the next generation of artists after Masaccio and Donatello, including his pupils Botticelli and Filippino Lippi (his son).

The Barbadori Altarpiece, commissioned in 1437, is one of the earliest datable examples of *sacra conversazione*, where attendant saints are grouped about the Madonna and Child not, as previously, in separate panels, but in a single unified space. From the 1450s, Lippi painted a series on the theme of the Madonna adoring the Christ Child in a woodland setting: this painting is the first of the series and may also be regarded as an extrapolation of the *sacra conversazione*.

Lippi traveled widely throughout Italy, which gave him the opportunity to see many works by different artists. He spent a year in Siena in 1428 and in 1434 he left Florence for Padua, where he spent around two years. Thereafter there is a gap in the record until 1437, and some believe that he may have visited the southern Netherlands during this time. In 1452 he moved to Prato, where he began his celebrated cycle of frescoes for the choir of Prato cathedral, which he completed in 1464. During this period he produced several other works and enjoyed the patronage of the Medici, who obtained a dispensation for him to marry.

Fact

Filippo frequently ended up in court on charges of fraud and embezzlement. In 1456 he eloped with a nun from the convent in Prato, where he was chaplain, by whom he had a son and daughter.

53 in (134 cm)

54 in (137 cm)

1437	1452–64	1455	1458
Commissioned to paint *The Barbadori Altarpiece*, which was inspired by Masaccio's *Trinity*	Paints a fresco cycle in Prato cathedral	Lippi confessed to forging a receipt for payment after being tortured on the rack	Completes a painting for the King of Naples, brokered by the Medici

Despite the controversy of his private life, or perhaps because of it, his later works were highly religious and were more lyrical than his earlier works—the series of nativities exemplifies this. The influence of Netherlandish painting is here evident in the rich colors, linear design, and attention to detail, while his Florentine training is demonstrated by the strong modeling of the figures— especially Joseph—the use of perspective to create the illusion of distance, and the pyramidal composition. He has created the illusion of distance behind the figures with an imaginative spatial design comprising architectural ruins, trees, and rocks.

Joseph is not looking at the Child but gazing abstractedly at the ground in front of him in the classic melancholic pose.

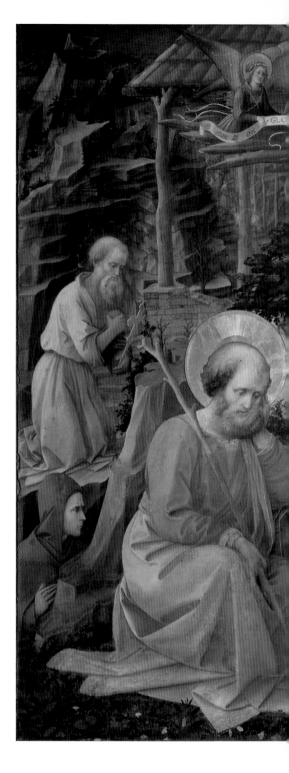

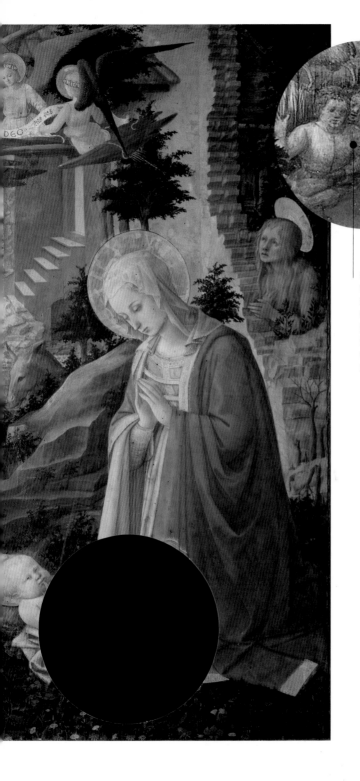

Centrally placed in the background are these two rather odd figures, leaning on the wall: one appears to be waving at us, while the other is looking away.

To prevent the figures of the Madonna and Child from totally dominating the picture, Joseph's robes are in strong colors of blue and brilliant orange, shaded to model the figure and give it solidity and form. His figure in the foreground balances the composition visually.

Colors are used as a spatial device—thus the brilliantly clothed figures of Mary and Joseph, and those of the angels above, serve to bring them forward and emphasize the pyramidal composition. The more muted colors of the saints set them farther back, while swathes of greenery around and between the figures unite the composition while indicating space between them. The intensity of the colors enhances the overall decorative effect and also emphasizes the fantasy aspects of the composition. Color contrasts are used to indicate linearity and isolate the principal figures, thus the sweep of the Madonna's blue cloak is set against pale-gray stonework, while Jerome's pale-robed figure, illuminated from the left, is highlighted against dark rocks, and Hilarion's pale profile is framed with a dark background.

The flattened regularity of the squared folds of Joseph's robe, intersected by the staff, is indicative of Lippi's interest in line and surface patterns.

Yellow

Red

Blue

Green

Orange

The figures of the Holy Family are placed well forward, forming the bottom of the pyramid, while the figures of the saints (Hilarion and Jerome), along with the sweep of rock, lead the eye up to the group of angels at the top. Similarly, the line of the Madonna's back, reinforced by the angled wall, forms the other side of the triangle. Note how the left wing of the angel on the right points down toward the Madonna. Two smaller triangles are formed by the Madonna and Child on the right and the group of Joseph, Jerome, and Hilarion on the left. Here the line of Joseph's staff and the sweep of rock behind him form two sides of the triangle. The combination of large figures placed in the foreground with the high horizon creates a somewhat claustrophobic sense of distance, in keeping with the woodland setting. The meticulous details of clothing and landscape are reminiscent of Netherlandish painting.

The folds of red material that envelop the Child and appear almost to flow from the Madonna's robe are symbolic of the act of birth.

Pale coloring and strong highlighting of the Christ Child's body give him an almost luminous quality.

The perspectival device of the flight of steps leading to a doorway on the right was also used in the *Pitti Tondo* of 1452.

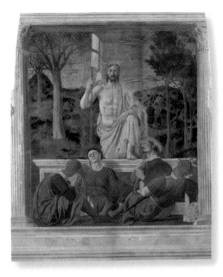

PIERO DELLA FRANCESCA, c.1415/20–92

The Resurrection of Christ
c.1460, fresco, Borgo San Sepolchro

LONG NEGLECTED, PIERO DELLA FRANCESCA was "discovered" as a major artist of the Renaissance in the 20th century. In tastes formed by Cubism, the rather austere serenity and calm of his art, with its geometric shapes and pale, flat colors, greatly appealed—he is now one of the most popular artists of the 15th century.

Aside from technical aspects, part of this appeal undoubtedly lies in the enigmatic nature of his paintings, which often include mysterious figures and unexplained, difficult-to-read actions. *The Flagellation* is a good example of this, where the main action is relegated to the background and three unknown figures are given prominence in the foreground—iconographically it is a mystery. In this regard it is worth noting that he, like Fra Filippo Lippi, worked with Domenico Veneziano.

1300–1400	1439	1440
Polyptych of the Resurrection in the cathedral of Borgo San Sepolcro probably inspired Piero's version	Piero in Florence working with Domenico Veneziana	Paints *The Baptism of Christ*, the center of an altarpiece for San Sepolchro Cathedral

As a religious work, we might expect *The Resurrection* to be an altarpiece for a church but in fact it was painted for the council chamber of the town hall of Borgo San Sepolcro, Piero's hometown and modern-day Sansepolcro. The painting combines civic and religious symbolism and reflects the changing politics of the time, whereby many towns and corporations invoked the protection of holy patrons, as if to reinforce their independence from secular domination. Thus local patriotism combines with religious devotion.

According to tradition, the town grew up around an oratory founded in 934 by two pilgrims returning from the Holy Land with relics from Christ's sepulcher. In keeping with the new humanist religious imagery, Christ is depicted as the suffering Son of Man, rather than the earlier feudal imagery of the transcendental Christ. *The Resurrection*, therefore, is an entirely appropriate subject for its location. This is underlined by the fact that it faced the doorway onto the street, which is where Christ's gaze is directed. He could be seen, therefore, to step from his sepulcher into San Sepolcro. This is a typical Renaissance conceit.

The work is undocumented but it is believed that the fresco was moved shortly after its completion and that it suffered some damage—notably to the inscription and the framing elements—as a result.

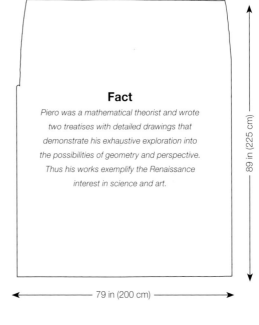

Fact

Piero was a mathematical theorist and wrote two treatises with detailed drawings that demonstrate his exhaustive exploration into the possibilities of geometry and perspective. Thus his works exemplify the Renaissance interest in science and art.

89 in (225 cm)

79 in (200 cm)

1452	1452–58	1458	1478
Paints *The Flagellation*. Its interpretation is the subject of much speculation	Piero's masterpiece—the fresco cycle in the Church of S. Francesco, Arezzo	*The Resurrection* is painted, probably before Piero leaves for Rome in 1458	The last record of Piero as a painter concerns a lost fresco. Thereafter he concentrated on mathematics

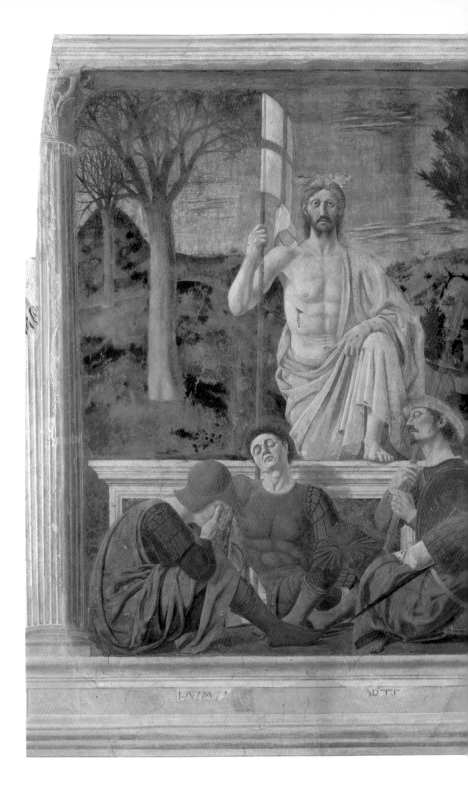

This celebrated work is a powerful evocation of a familiar religious theme. The composition is pyramidal with the jumbled, disorganized group of soldiers along the bottom, contrasted with the serene and commanding figure of Christ above. Their listless passivity is juxtaposed with Christ's animation as he steps forcefully from his tomb—the depth requiring a deliberate effort on his part. The color scheme further enhances the contrast with the soldiers grounded in earth pigments, while Christ's deathly pale body, swathed in pale, bright pink, forms a link with the pearly blue of the sky indicating his divine nature. The figure seems almost to radiate light and this luminous quality is emphasized by the dark contrast of the landscape.

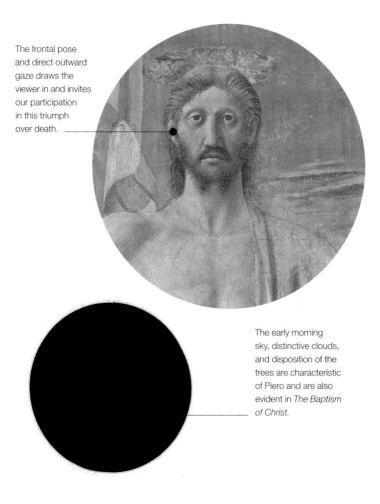

The frontal pose and direct outward gaze draws the viewer in and invites our participation in this triumph over death.

The early morning sky, distinctive clouds, and disposition of the trees are characteristic of Piero and are also evident in *The Baptism of Christ*.

Piero's painting is renowned for its luminous quality and use of pale, flat colors. His early works tended toward more saturated tonalities. He retained the use of earth colors for clothing and hair, while developing paler, more translucent colors in order to evoke the mysterious atmosphere, which is characteristic of his paintings.

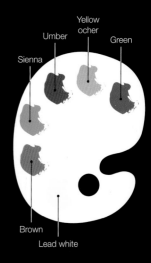

Sienna

Umber

Yellow ocher

Green

Brown

Lead white

The depiction of early morning light, with a pearly translucent sky and distinctive clouds, is characteristic of Piero and can also be seen in earlier works, such as *The Baptism of Christ* (1440). He has painted the soldiers in earth pigments—mainly greens and browns—and placed them on an earth-brown ground to emphasize their earthly nature. They are framed by the lighter, creamy colored architectural elements, achieved by mixing lead white with earth pigments, such as yellow ocher. Flesh tones are achieved by the use of green earth underpainting, and over this lead white mixed with other pigments. Unfortunately, lead white can become transparent with age, allowing the green earth pigment to show through.

The modern names for earth pigments include terre verte, raw and burned sienna, raw and burned umber, yellow ocher, and Venetian red.

The disposition of the figures in the foreground heightens the sense of immediacy and identification with the scene. There is no viewing point drawing our eye to the horizon, instead the line of the horizon is high and flat, serving as a backdrop and pushing the monumental figure of Christ forward into a stark relief—we gaze up at him in awe. The lines of trees on either side, Christ's staff, and the diagonals formed by the soldiers' limbs, direct our gaze downward from where Christ has arisen. Light is used to model forms and in perspective to create the illusion of recession, while calculated use of light and shade enhances the characteristic mysterious, otherworldy atmosphere. A variety of brushstrokes is used to create different effects: broad, looser strokes on Christ's shroud; long, distinctive strokes for his hair; softer strokes for the beard; close, precise, and almost invisible strokes for the marble effect of his uncovered body.

Piero's effects of light and shade come from retouching with metal pigments *a secco*. In places these have been lost—as is evident here where leaves are missing.

The monumentality of Christ's figure is reinforced by juxtaposing him with the tree trunk on the left—a device employed previously in *The Baptism of Christ*.

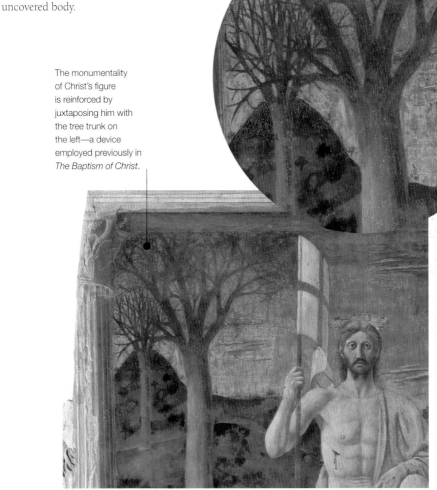

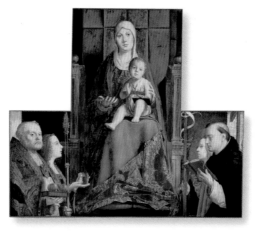

ANTONELLO DA MESSINA, c.1430–79

S. Cassiano Altarpiece

1475, oil on panel, Kunsthistorisches Museum, Vienna.
Originally in the Church of S. Cassiano, Venice

ANTONELLO IS CREDITED WITH INTRODUCING the Netherlandish technique of oil painting, developed by Jan van Eyck, into northern Italy. Indeed, according to Vasari, he visited the Netherlands where he trained under van Eyck. However, this seems unlikely since Antonello was born (in Sicily) around 1430 and van Eyck died in 1441. Had he traveled to the Netherlands as a young man (c.1450), then he would have more likely encountered Rogier van der Weyden—however, there is no evidence that he did. It is possible that the technique was "carried" south by artists such as Rogier or Piero della Francesca, or that he learned from paintings by Netherlandish painters, such as van Eyck, in the collection of Alfonso I. Certainly he achieved clear mastery of the technique, as evidenced by his first dated work of 1465, *Salvator Mundi*.

1475	c.1483–5	1505
Antonello visits Venice and paints the *S. Cassiano Altarpiece*	Giovanni Bellini's *S. Giobbe Altarpiece*	Giovanni Bellini's *S. Zaccaria Altarpiece*

In 1475 Antonello visited Venice, where he was commissioned by the Venetian patrician Pietro Bon to paint an altarpiece for the church of S. Cassiano. Unfortunately this now only survives in fragments held in the Kunsthistorisches Museum in Vienna. However, by using copies of fragments now lost, plus engravings of these copies made in 1658, the prominent art historian Johannes Wilde (1891–1971) in 1929 proposed a reconstruction of the likely appearance of the altarpiece. This reconstruction shows the Virgin and Child raised on a throne, beneath the domed crossing of a church, above the surrounding saints, who are grouped either side: on the left, George, Rosalia, Nicholas of Bari, and Mary Magdalen; on the right, Ursula, Dominic, Helena, and Sebastian. Furthermore, the saints are arranged such that the two soldiers, Sebastian and George, are placed at the front outside edge of the grouping, while the representatives of organized religion, Nicholas and Dominic, are next; and the female saints are farthest in toward the apse. The architecture represented in the painting reflected the real architecture of the church and so gave the illusion of a "virtual" chapel as an extension to real space—a further development of Masaccio's *Trinity*. This format, known as *sacra conversazione*, was not an entirely new one—examples already existed by Fra Lippi and Fra Angelico—but it was immensely influential. Antonello's unique contribution was his synthesis of the Netherlandish (color, light, and texture) and the Tuscan (architecture, space, and perspective) styles to create a completely new idiom.

Fact

Two similar altarpieces from the mid-1470s are the Brera Altarpiece by *Piero della Francesca* and one by *Giovanni Bellini* for SS Giovanni I Paolo, now destroyed. The S. Cassiano Altarpiece *became the archetype for subsequent altarpieces by the most prestigious artists, including Giovanni Bellini (for example, San Giobbe) and Giorgione.*

45 in (115 cm)

73 in (185 cm)

c.1600	1658	1700	1929
S. Cassiano Altarpiece disappears from the church	Engravings are made from copies by David Teniers for *Theatrum Pictoricum*	Three or so large fragments arrive in Vienna	Two side panels are discovered by Wilde and a reconstruction of the piece is made

This new form of *sacra conversazione* forges a more intimate relationship with us, the viewers, who, standing in front of the painting, feel as if we are sharing the same space. Furthermore, the outward-directed glances of the Virgin, Child, and Nicholas, and the hand gestures, seem to invite us to participate in the scene.

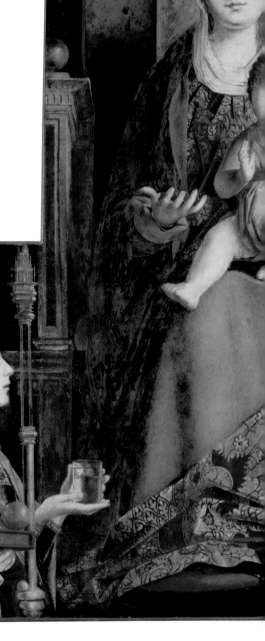

Compositionally, the spatial unity of the group is reinforced by the way light is used. Psychological harmony is suggested by an unspoken communion between the figures illustrated by gesture and counter-gesture: the Virgin offers red grapes in her outstretched right hand, symbolizing the wine of the communion, and Mary Magdalen responds by offering her a glass of water to wash them. Dominic is reading an open book, the Child holds an open book, while Nicholas holds a closed book and looks out at us. The Child too is looking at us and raising his hand in a blessing. The picture is beautifully balanced with the pyramidal form of the Virgin and Child echoed in the hierarchical structure of the overall group. An interest in geometric form is evident in the perfect oval of the Virgin's head and the sphere of the Child's head, while the body of the Child is composed of various cylinders: larger for the torso and smaller for the limbs.

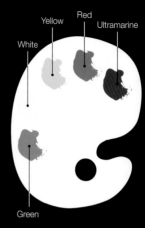

White Yellow Red Ultramarine

Green

Despite a limited chromatic range, Antonello has achieved a wide range of shades and tones. The effect serves to unify the composition, without compromising the visual experience, and the result is subtle and harmonious. His facility in reproducing the effects of light on various surfaces is exquisite.

Using the oil medium in the Netherlandish manner, Antonello was able to depict the details of surface and texture in startling realism. The use of highlighting and layers of translucent glazes produces shimmering, glittering, glowing effects. The brilliantly detailed brocade of the Virgin's gown evokes the richness of the material, while the folds shimmer as they catch the light, contrasting with the warm glow of the burnished throne. The stark, brilliant blue of her cloak, now somewhat faded, emphasizes the triangular composition and solidity of her body. It serves to isolate her, while the tumbling brocade forms a link with the saints—especially Magdalen and Dominic in gold-embossed brocaded robes and glittering crozier.

The ivory complexion of the red-headed Mary Magdalen is luminous next to the warmer skin tones of Nicholas.

Antonello's interest in light is evident in the transparent glass of water held by Mary Magdalen and the reflective surfaces of Nicholas's crozier.

Antonello combines Netherlandish technique and realism with Italian modeling of form and spatial arrangement. He achieves his subtle range of colors and tones because of the properties of the oil medium. For one thing, oil colors can be transparent and, when applied in layers, this means that light penetrates the outer layers and is reflected from a lower layer, which gives a luminous quality. Thus it is possible to combine transparent and opaque effects, glaze, and body color. Also, because oil is slow drying, the colors can actually be blended on the surface of the painting. Brushwork can then be used to soften edges, as with Mary Magdalen's hair and the shading on the faces of the two male saints.

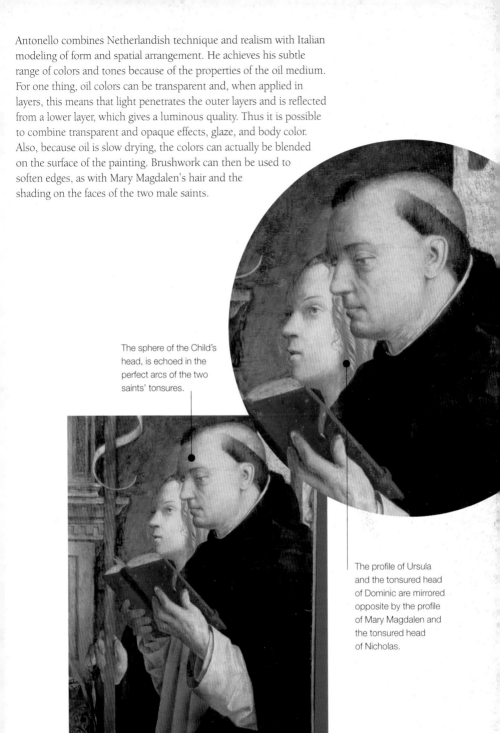

The sphere of the Child's head, is echoed in the perfect arcs of the two saints' tonsures.

The profile of Ursula and the tonsured head of Dominic are mirrored opposite by the profile of Mary Magdalen and the tonsured head of Nicholas.

ANTONIO DEL POLLAIUOLO, c.1432–98 AND PIERO DEL POLLAIUOLO
c.1441–BEFORE 1496

The Martyrdom of St. Sebastian

1475, oil on poplar, National Gallery, London. Originally in the Oratory of St. Sebastian, Florence

THE BROTHERS ANTONIO AND PIERO WERE THE SONS of a Florentine poulterer—hence their nickname, Pollaiuolo. From about 1460 until they transferred to Rome in 1484, they ran one of the busiest and most successful workshops in Florence, producing a wide range of works: bronze sculpture, goldsmiths' work, paintings (fresco and panel), drawings, and engravings. Antonio trained as a goldsmith and sculptor, but he also had a reputation as a painter. Piero was trained as a painter, possibly with Andrea del Castagno.

The brothers worked together and so it is hard to separate their individual contributions, though Antonio is generally recognized as the more talented.

1450s	1460	1466
Oratory to St. Sebastian is built by Pucci family	Antonio described by Jacopo Lanfredini as "the leading master of this city, and perhaps of all time…"	Outbreak of plague

Antonio's major contribution to Renaissance art lay in his studies of the male nude, especially their muscular physicality, through drawings and engravings, which were much copied and imitated. Indeed, he is reputed to have dissected corpses in order to study human anatomy. This placed him at the forefront of the scientifically minded painters following after Donatello and before Leonardo. He was, therefore, an important stimulus to High Renaissance painters and sculptors, like Michelangelo and Raphael.

The *Martyrdom of St. Sebastian* was the brothers' most important painting. It was commissioned by the Pucci family for their oratory of St Sebastian in the church of Santissima Annunziata in Florence, which contained a relic of the saint's arm bone. It was possibly a votive piece connected to the plague of 1466—Sebastian was associated with protection from the disease. Sebastian was sentenced to death by Emperor Diocletian for being a Christian. He is shown tied to a tree, while archers use him for target practice. The figurative groups represent clearly Antonio's skill in depicting the male nude and, in particular, his engraving, *The Battle of the Ten Nudes* (1475), which similarly shows various figurative mirror-images against an intricate background of vegetation that demonstrate his draftsmanship.

This painting can be seen as part of the debate on the relative merits of painting and sculpture that became so popular around this time. It also demonstrates the shift that occurred in the 15th century from valuing materials in art, to a preference for skill and technical knowledge.

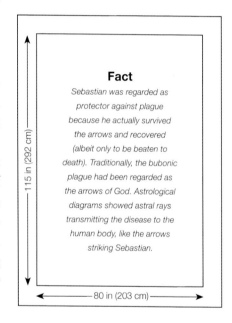

Fact

Sebastian was regarded as protector against plague because he actually survived the arrows and recovered (albeit only to be beaten to death). Traditionally, the bubonic plague had been regarded as the arrows of God. Astrological diagrams showed astral rays transmitting the disease to the human body, like the arrows striking Sebastian.

115 in (292 cm)

80 in (203 cm)

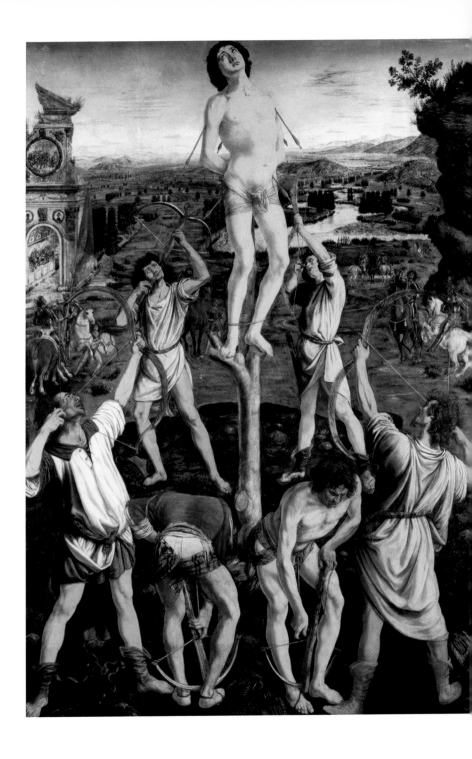

The composition is symmetrical about a vertical axis. The foreground group forms a regular pattern about a steep triangle. The placement and poses of these figures are rather contrived. Thus the pair of crossbowmen are the same figure turned through 180°, while the two front archers and the one at the back on the right are also the same figure seen from different angles. The fourth archer is apparently based on an ancient Roman sculpture (one of the Dioscuri). The figure of Sebastian references the crucified Christ but is also based on ancient Greek statues set up to commemorate athletic prowess. The triumphal arch in the background is another antique reference. Inside the triumphal arch and below the coffered ceiling is a sculpted battle relief, such as would have appeared on ancient sarcophagi.

The panoramic landscape is a brilliant evocation of the Arno valley around Florence.

On the façade is a round sculpted relief set within a laurel wreath, possibly based on Antonio's drawing, *Prisoner Led Before a Judge*.

One characteristic of the work of the Pollaiuolo brothers is the delicacy with which the details and chromatic tones are blurred and graduated. This produces the hazy effect, which is known as "aerial perspective."

Blue

Gray/blue

Green glaze

Red

White

Yellow

Green

The vibrancy of the colors in the men's sashes is achieved through fluid handling of transparent pigments made possible by using an oil medium.

Pale color, highlighting, and soft modeling convey the soft, pale flesh of the saint, which emphasizes his vulnerability and separation from his would-be executioners. Their flesh is rendered in darker tones with strong modeling in light and shade to indicate their firm flesh and strong musculature. Similarly their colorful clothing reveals rather than hides their bodies. This is achieved through the drapery, which again is skillfully rendered in varying lighter and darker tones, subtly blended to create an almost shimmering effect—note the brilliant blue jerkin of the left-hand archer and the greens on the robe of the right-hand archer. Seen close up, the robe of the right-hand archer at the back is an exquisite blend of pink and gray.

Linear perspective is employed in the architectural ruins to provide spatial recession and lead the eye toward Sebastian. Aerial perspective, where colors are paler toward the horizon, gives a sense of distance and resembles the vistas of Netherlandish paintings.

Mirrored forms establish depth of space within each group and also between them—for example, between the foreground figures and the pairs of horsemen.

The Pollaiuolo brothers were at the forefront of experimentation in the use of oils but this early effort was not entirely successful. Technical analysis of the painting indicates the presence of a walnut oil medium. However, at this stage the brothers did not fully appreciate the Netherlandish technique and instead of building up the layers by careful application of thin translucent glazes, they apparently, in places, premixed the colors as in tempera and applied them thickly with broad brushstrokes. As a result, the slow-drying pigments have "bubbled up" in places. Additionally, the green glazes on the horizon have discolored where there is no opaque underpainting. Other parts are more successful as in the tonal changes over the receding landscape, the glittering river, and the shining armor of the horsemen.

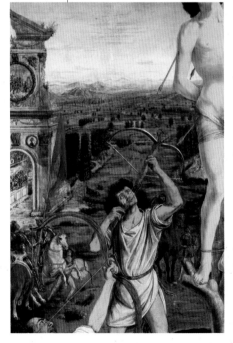

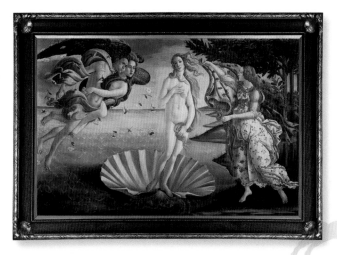

SANDRO BOTTICELLI, 1445–1510

The Birth of Venus
c.1485, tempera on canvas, Uffizi, Florence

BOTTICELLI (HIS NICKNAME MEANS "LITTLE BARREL") was a highly esteemed artist in his day, closely linked to the Medici family. He was trained by Fra Filippo Lippi and, in turn, trained Lippi's son, Filippino. During the 1470s he came under the influence of the Pollaiuolo brothers and, in 1470, completed *Fortitude* to go with a series of *Virtues* by Piero Pollaiuolo. From 1478 to 1490, he painted his famous mythologies—among them were the *Primavera* and this one, *The Birth of Venus*. Despite prolonged research, the precise meanings of these paintings remain a mystery—not least because they were unprecedented.

Although apparently a straightforward depiction of a well-known myth, in fact *The Birth of Venus* is an elaborate Neoplatonic interpretation. The Neoplatonists endeavored to reconcile classical mythology with Christianity,

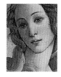

1470	1472	c.1477
Botticelli completes the Pollaiuoloesque *Fortitude* for the series of *Virtues* by Piero Pollaiuolo	Botticelli joins the confraternity of Florentine painters	*Primavera* is the first of Botticelli's mythologies

believing that classical mythology contained secret wisdom veiled in allegory, which, if it could be deciphered, would reveal profound truths. Metaphors and symbols were used to disguise hidden meanings that were only accessible to initiates. Thus concealment was deliberate, and consequently this, and the other mythological works, were not intended for the public but, rather, to be hung in private rooms. They are symptomatic of the complex cultural life of Renaissance Florence in the late 15th century. According to scholarly interpretation, the story of the birth of Venus symbolized the mystery through which the divine message of beauty came into the world. Thus Love is a creative force, which emanates from God.

The Birth of Venus is thought to have been commissioned for a cousin of Lorenzo the Magnificent, the young Lorenzo di Pierofrancesco de'Medici, who had been taught by the humanist scholar and Neoplatonist Marsilio Ficino (1433–99) at the Florentine Academy, named after Plato's school of philosophy in Athens. The Academy continued to be a rich and influential source for images in the 16th century—Botticelli's mythologies were at the forefront of a new era of allegorical paintings.

Fact

The model for Venus was reputedly "la Bella Simonetta," a mistress of Giuliano de'Medici, who was murdered in the Pazzi conspiracy of 1478. Legend has it that Botticelli was also in love with her—though her death predates the Birth of Venus.

68 in (173 cm)

110 in (279 cm)

1481–82	c.1485	1815	1860s
Botticelli, with Perugino, Ghirlandaio and Roselli, decorates the walls of the Sistine Chapel	Birth of Venus is the last of Botticelli's mythologies	Birth of Venus acquired by the Uffizi, Florence	Primavera and The Birth of Venus exhibited for the first time in the Galleria dell'Accademia, in Florence

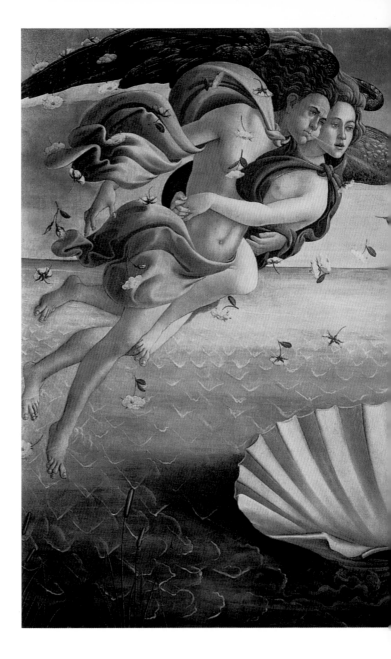

Centered in the composition, Venus, in the pose of *Venus Pudica*, floats to shore on a shell, which is her attribute. She is propelled by the gentle breath of Zephyr, the west wind of springtime, who is holding his wife Chloris, the Greek goddess of flowers, while unsullied white roses, sacred to Venus, fall around them.

On the right, the Roman goddess of flowers, Flora, prepares to meet Venus. She wears a white dress patterned with blue flowers, her waist is bound by rose

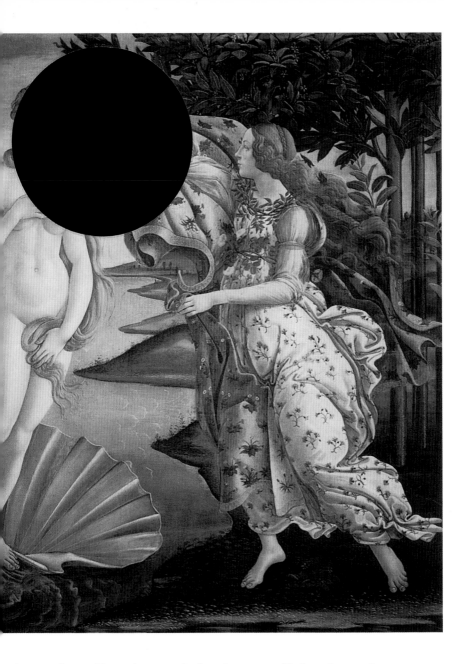

briars, and around her neck is a wreath of myrtle, evergreen like love, also sacred to Venus. She holds out a voluminous red cape decorated with white flowers, to envelop the naked form of Venus, whose long golden tresses are grasped in her left hand in an attempt to hide her *pudenda*. Her exquisite body sways languorously as she is about to step off the shell, producing an unforgettably lyrical and poetic image. The whole composition is harmonious and beautifully balanced.

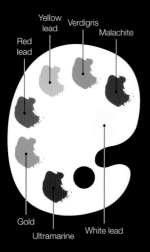

Red lead

Yellow lead

Verdigris

Malachite

Gold

Ultramarine

White lead

The face of Chloris, like Venus, resembles white porcelain with coral lips, and faint blushes of pink on cheeks, nose, and chin.

Figures are given volume and substance through modeling dark and light tones. Minute brushstrokes make gradations almost invisible, endowing the flesh with a marble quality.

Botticelli's sense of color is superb and conforms to Albertian principles—thus each figure has different colored drapery: Flora in white holding a pink-red cloak, and, appropriately, Chloris in green, and Zephyr in blue. According to Alberti, a rose color next to green or blue, as here, gives "beauty and seemliness," while white "produces a fresh and graceful effect." Botticelli also modulated the tones of his colors such that they are paler toward the horizon, indicating distance (aerial perspective). Unfortunately many of his paintings have become discolored over time and here we see, in the bottom right-hand corner, chromatic darkening resulting in excessive contrast. His greatest expertise is in the rendering of flesh tones, where he has used layers of semitransparent ochers, whites, and cinnabars.

Botticelli used the finest pigments, which he applied in thin, opaque layers known as "scumbles." As the layers were built up, they acquired a luminous, enameled effect with multiple gradations of tone. He often used glaze on reds and dark greens.

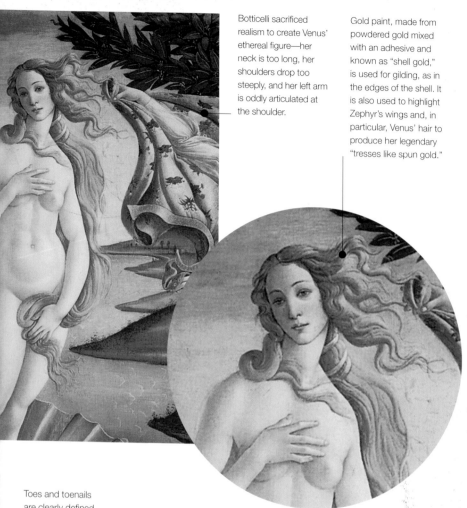

Botticelli sacrificed realism to create Venus' ethereal figure—her neck is too long, her shoulders drop too steeply, and her left arm is oddly articulated at the shoulder.

Gold paint, made from powdered gold mixed with an adhesive and known as "shell gold," is used for gilding, as in the edges of the shell. It is also used to highlight Zephyr's wings and, in particular, Venus' hair to produce her legendary "tresses like spun gold."

Toes and toenails are clearly defined, though it is just possible to see where the line of Zephyr's right foot has been adjusted slightly.

The elegant, courtly style that Botticelli strived for during the period of his mythologies here reaches perfection. With contraposto poses, graceful proportions, and subtle contours, his figures are lyrically sensuous. This is due in large part to his linear quality—they are not so correctly drawn as Pollaiuolo's or Masaccio's but somehow this doesn't matter. Their rhythmic quality creates a pleasing pattern across the surface. He was an accomplished draftsman and allowed his line to characterize his figures. He executed two underdrawings in black ink and wash. The first was applied directly onto the gesso-coated surface, foundation colors were then applied, followed by a second drawing to adjust and redefine the contours. Placement of hands and feet, in particular, was a focus for attention.

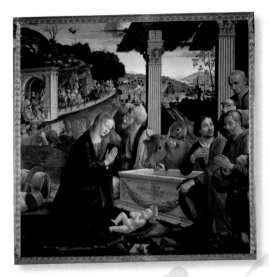

GHIRLANDAIO, 1449–94

Adoration of the Shepherds
1485, panel, Sassetti Chapel, S. Trinita, Florence

GHIRLANDAIO, BORN DOMENICO DI TOMMASO BIGORDI, gained his nickname from his father's skill in making garlands. He was the best fresco painter of his generation in Florence and headed a successful workshop, along with his two brothers. Michelangelo was apprenticed to him for three years and was thereby able to learn the very best techniques of fresco painting and expert draftsmanship.

His characteristic style blended the contemporary with the historical, the worlds of the sacred, the antique, and the everyday. Ghirlandaio's detailed narratives usually included portraits of leading citizens that appealed to the vanity of his middle-class patrons and earned him the major Florentine commissions to decorate the Sassetti Chapel, S. Trinita (1482–85), and the

1478–79

Decoration for Sassetti
Chapel commissioned

1481

Ghirlandaio is
summoned to Rome
to work on the walls
of the Sistine Chapel

1482

Work on the Sassetti
Chapel commences

Tournabuoni Chapel, S. Maria Novella (1486–90). These works confirmed his stature as one of the foremost painters of the late-15th century. Significantly, in consideration of these works—more particularly the Sassetti Chapel—he was summoned to Rome in 1481, together with other artists, to work on the decoration of the walls of the Sistine Chapel. This allowed him the opportunity to study, at first hand, the Roman antiquities such as triumphal arches and other ancient buildings, Roman sarcophagi, and classical motifs, which he later used in his Florentine commissions.

His patron for the Sassetti Chapel was Francesco Sassetti, an agent of the Medici bank. The six main frescoes depict scenes from the life of St. Francis, Sassetti's patron saint. The centerpiece of this scheme is this altarpiece of the nativity, featuring the adoration of the shepherds, above which, in the lunette, is *Confirmation of the Rule of St. Francis*, containing portraits of Francesco and Federigo Sassetti, Lorenzo de'Medici, and his young sons. In the middle tier, directly above the altarpiece, is the large panel of *The Raising of the Roman Notary's Son*. Below this on either side of the altarpiece, kneel the figures of Francesco Sassetti and his wife Nera, whose poses echo those of the Virgin and shepherds within the altarpiece, just as those of the figures in the fresco above also look onto a central religious event. On both the side walls of the chapel are the sarcophagi intended for Sassetti and his wife that allude to the sarcophagus within the altarpiece itself.

Fact

At this period, it was not uncommon for the wealthy who aspired to scholarly pretensions, like the Sassetti and the Medici, to demonstrate their culture and erudition by collecting Latin manuscripts, inscriptions, and coins.

68 in (172 cm)

68 in (172 cm)

1483	1485	1485	1486–90
The Portinari altarpiece by Hugo van der Goes arrives in Florence	Christmas Day: The Sassetti Chapel is consecrated and dedicated to the birth of Christ	*Adoration of the Shepherds* altarpiece completed	Completes his other major Florentine commission—the decoration of the Tornabuoni Chapel, S. Maria Novella

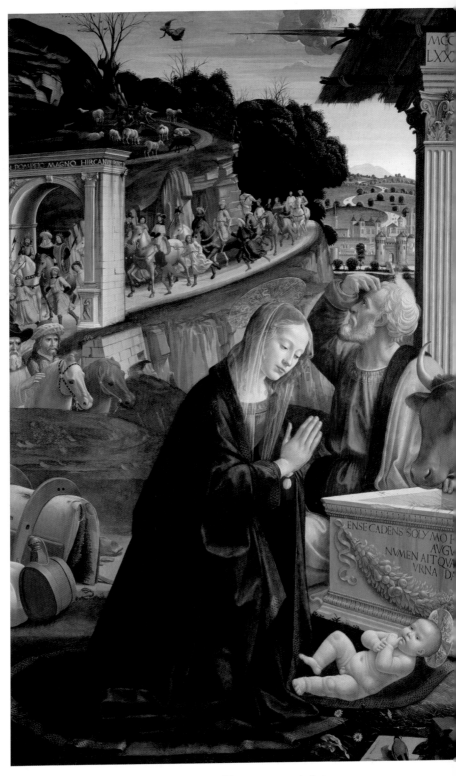

The composition owes much to Northern, particularly Flemish, influences—the naked Child lying on the ground is reminiscent of Northern nativities and was seen earlier in those of Lippi. Ghirlandaio pays homage to Hugo van der Goes by imitating the shepherds in his Portinari altarpiece that had been brought to Florence by a friend of Sassetti's, Tommaso Portinari, in 1483. The foremost shepherd is thought to be a self-portrait of Ghirlandaio, who is thus placed closer to the Christ child than the donors—they kneel outside the confines of the altarpiece. He is indicating the miracle of Christ's birth to the remaining shepherds, and thus to us too. Classical influences are evident in the triumphal arch, two superbly drawn Corinthian pillars, and the sarcophagus. The gilded frame consists of two decorated pilasters supporting a classical entablature containing a Latin inscription in the frieze.

The Latin inscription on the sarcophagus, which is being used as a crib, ends with the prophesy that it will "bring forth a god."

The right hand is indicating himself and the left, although pointing at the Child, also indicates the garland, which is another self-reference.

Ghirlandaio was also a goldsmith and mosaicist, which perhaps accounts for his good sense and feel for color. Colors are warm and harmonious, with a wide range of hues and tones. Where brighter pigments are used, he often contrasts complementaries.

Note the rhythmic use of rose pink among the animated procession—repeated on Joseph's the Virgin's dress, and finally, the Child's halo.

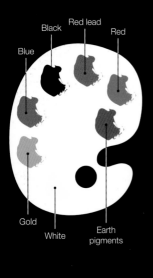

Blue

Black

Red lead

Red

Gold

White

Earth pigments

The only gilding painting is on th Instead, reflectir changing trend, used for the fra

There is a shift away from the conspicuous use of expensive pigments. The Renaissance eye was especially tuned to differentiating between colors and their worth. They were well aware that there were expensive colors, such as blues ground from lapis lazuli and reds made from silver and sulfur; and there were cheap colors like the earth pigments. They could even differentiate between grades of lapis lazuli—the best being from the first "washing," which gave a rich violet blue. Consequently, early Renaissance patrons often specified the grade and quantity of pigments, as well as gold and silver. Usually the Virgin is swathed in an ultramarine cloak from lapis but here, the emphasis is on the rich quality of the material.

Throughout the 15th century, the trend away from flaunting expensive materials led to a demand for skill of execution. Instead of specifying particular pigments, a patron might stipulate a representational background instead of a plain or gilded one. In the contract between Tournabuoni and Ghirlandaio, the patron even listed what details he wanted, including: "buildings, castles, cities, hills, birds." Here, too, there is a wealth of detail in the middle and background. Notwithstanding this, the figures and space are carefully organized to emphasize depth, introduce variety, and balance figural arrangement. The kneeling figure of the Virgin, hands joined in prayer, is balanced by the shepherd on the right, while the downward bent arm of the front shepherd is echoed by the dramatic upward gesture of Joseph.

There is a rather strange miniature subplot going on here, where a Mary Poppins-like angel hovers above alarmed shepherds, while, close by, two unconcerned figures are at the edge of the cliff watching the spectacle of the procession pass beneath.

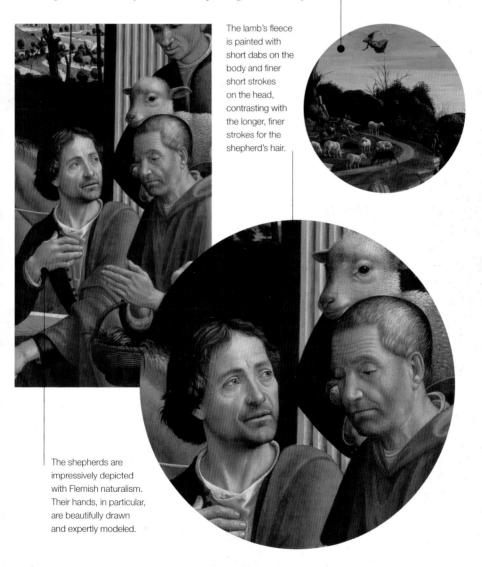

The lamb's fleece is painted with short dabs on the body and finer short strokes on the head, contrasting with the longer, finer strokes for the shepherd's hair.

The shepherds are impressively depicted with Flemish naturalism. Their hands, in particular, are beautifully drawn and expertly modeled.

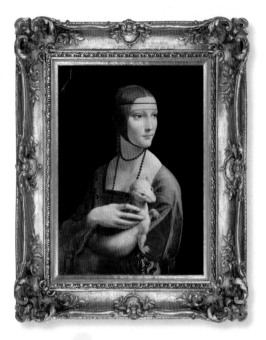

LEONARDO DA VINCI, 1452–1519

Portrait of a Young Woman with an Ermine
c.1492, oil on wood, Czartoryski Museum, Kraków

LEONARDO WAS THE ILLEGITIMATE SON OF A TUSCAN NOTARY and was brought up in his paternal grandfather's house. He was trained by Andrea del Verrocchio, an extremely accomplished sculptor and painter. Leonardo was, undoubtedly, a genius—a man of formidable intelligence and abilities. Sadly, his inquiring mind sidetracked him on to so many different projects that he completed very few. Despite this, his known works were immensely influential throughout Europe and he was recognized as a great talent in his own time.

1474

Leonardo paints the portrait of *Ginevra dei Benci*

1483–99

Leonardo living and working in Milan

1501–17

Leonardo paints the *Mona Lisa*

Of relevance to a discussion about *Portrait of a Young Woman with an Ermine*, painted around 1492, is the earlier portrait of *Ginevra dei Benci* (c.1476) and the later *Mona Lisa* (c.1502). The former shows how Leonardo developed his portrait style, while the latter shows how he continued to develop it, which informs our understanding of this painting. All three demonstrate his interest in how character, thoughts, and feelings are revealed by pose and facial expression—the latter responding to the former. Thus, in the earlier painting, he indicated Ginevra's shrewd character by firm chin and tight lips.

The subject here is probably the 17-year-old Cecilia Gallerani, a lady-in-waiting at the Milanese court and the mistress of Lodovico Sforza ("Il Moro"), Duke of Milan. There are several suggestions for the symbolism of the ermine—one is that it signals her chastity, though since she gave birth to Ludovico's illegitimate child in the same year that he married Beatrice d'Este, this would seem ironic. Another is that it is a pun on her name—which in Greek means "ermine." A third suggestion is that Ludovico's nickname was *Ermellino* or ermine, which was his heraldic animal. (Certainly in the *Ginevra dei Benci*, Leonardo indicated the sitter's name with a pun—the juniper bush behind her head—the Italian for juniper is *ginepro*.) Leonardo painted Cecilia's portrait during his first visit to Milan (1483–99), where he had traveled in the hope of securing the Duke's patronage.

Fact

The painting has been in Kraków for 120 years and has left the city three times: during WWI it was transferred to Dresden by Prince Czartoryski for safekeeping; in WWII plundered by the Nazis; and in 1992 exhibited in New York.

21 in (54 cm)

16 in (40 cm)

1717

The painting is bought by the Czartoryski family, having previously been in the Hague and Paris

1800

Works owned by the Czartoryski family from the mid-18th century, including this painting, exhibited in Kraków

1830

Russians condemn Prince Czartoryski to death for his part in the November uprising, and confiscate his property

1950

The Czartoryski Museum becomes state property

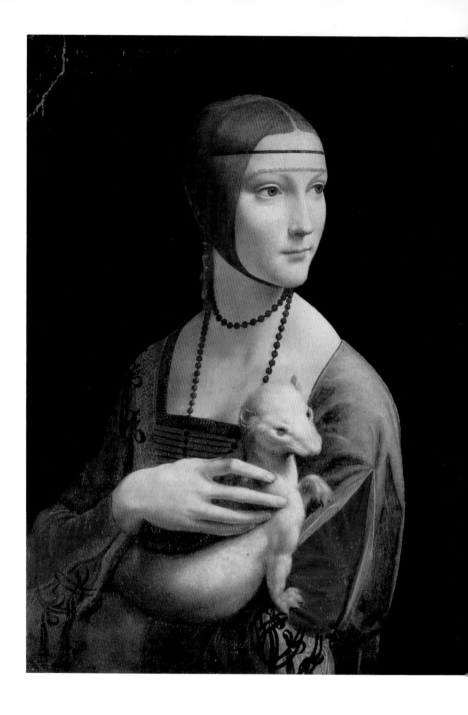

The ermine is a symbol of purity—the legend is that it died if its whiteness became soiled. It serves as an allusion to Cecilia's virtue and chastity.

Women's hands were usually represented with fullness and grace but here we see the results of Leonardo's anatomical exploration of muscle and bone.

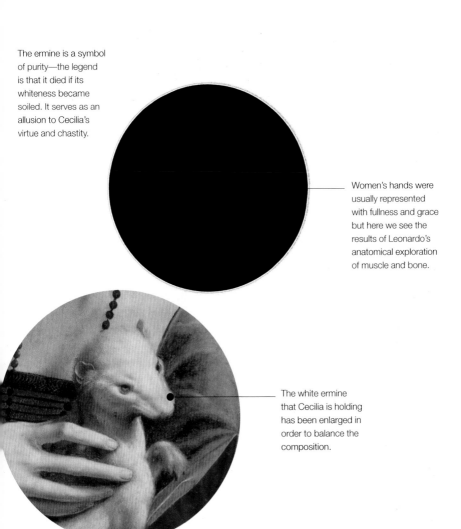

The white ermine that Cecilia is holding has been enlarged in order to balance the composition.

The composition is innovative and complex—Cecilia is shown turning her head from shade to light, her attention attracted outside the picture. This lends an active dynamic to the pose and piques the interest of the viewer—what has attracted her attention? By softly shadowing the corners of her mouth and eyes, Leonardo employs suggestive representation to give her face expression. The white ermine's brown eyes and sharp features somewhat uncomfortably mirror her own. This slightly disturbing effect is enhanced by her right hand with its curved, slightly claw-like fingers, replicated in the raised left paw of the ermine. Following his interest in frozen mime to tell a story, Leonardo uses pose and gesture to suggest something about the character of this young woman, but exactly what is left for us to interpret.

The light irradiates her face with its wonderful complexion and suggestion of a smile.

Despite some overpainting of the background, which was originally gray, the portrait is a harmonious blend of light and shade, line and color. It is diffused with a warm chromatic range, apart from the gray on her left shoulder, which is highlighted. Thus her left side is well defined while her right merges into the shadows. The gray serves to emphasize the claw-shaped slash of red on her left sleeve, which in turn is linked to the ermine and her right hand. The warm, mellow brown of her hair and eyes balances the colors of her right sleeve. For her dress and sleeves, shape is indicated by subtle transitions of blended colors within broad, faint contour lines—a technique known as *sfumato*.

Her face is exquisitely modeled in pale flesh tones with a faint blush of pink in her cheeks— the smooth, hard finish, somewhat reminiscent of Flemish painting.

Black

Red

Blue

Yellow

White

Leonardo developed the softly shadowed style of painting with an emphasis on tonal modeling rather than on bright colors. Over his career he reduced his color range and tended to use dark, smoky effects.

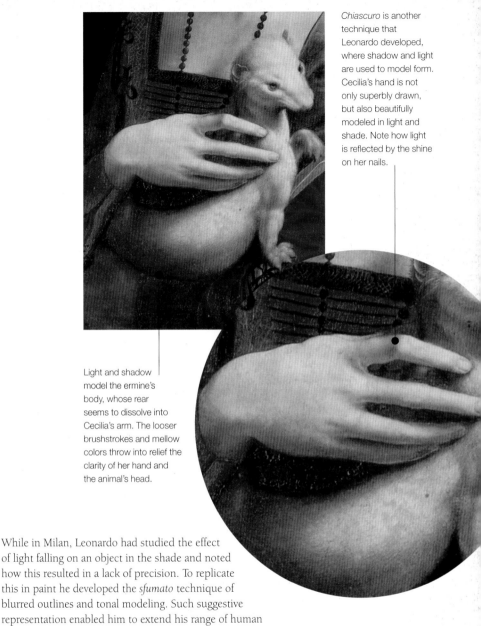

Chiascuro is another technique that Leonardo developed, where shadow and light are used to model form. Cecilia's hand is not only superbly drawn, but also beautifully modeled in light and shade. Note how light is reflected by the shine on her nails.

Light and shadow model the ermine's body, whose rear seems to dissolve into Cecilia's arm. The looser brushstrokes and mellow colors throw into relief the clarity of her hand and the animal's head.

While in Milan, Leonardo had studied the effect of light falling on an object in the shade and noted how this resulted in a lack of precision. To replicate this in paint he developed the *sfumato* technique of blurred outlines and tonal modeling. Such suggestive representation enabled him to extend his range of human expression by engaging psychologically with the viewer. By leaving something to the imagination, the viewers are required to make their own interpretation. It is this that makes his work so fascinating and enigmatic. He enhances this by applying another observation from nature—two sides of the face do not match. Thus Cecilia's left eye is smaller than the right, while the left corner of her mouth is turned up slightly more.

ALBRECHT DÜRER, 1471–1528

Self-portrait with a Landscape

1498, oil on panel, Museo del Prado, Madrid

ALBRECHT DÜRER HAS BEEN ACCLAIMED as the greatest German artist. His influence has been profound, not only on his contemporaries and followers in the 16th century but also right down to the present day. Primarily known for his prints, engravings, and woodcuts, he was also an accomplished painter. He was the son of a goldsmith from Hungary who had trained in the Netherlands and settled in Nuremberg, where Albrecht was born.

Early indications of his later genius are evident in a charming and extremely competent self-portrait at age 13 (1484) executed in the challenging medium of silverpoint. This was the first of a series of self-portraits, in drawings and in paint, that he produced over the course of his life, which provide an

1493	1494–95	1498
First of his painted self-portraits, aged 22	Travels to Venice for the first time	Second of his painted self-portraits, aged 26

invaluable insight into his character and personality, as well as his skill. The drawings are an intimate insight into Dürer's self-awareness, not intended for the public but for private viewing, while the paintings are more self-conscious— they depict Dürer as he wished to be seen.

After completing his apprenticeship, Dürer traveled for four years. He produced the first of his painted self-portraits in 1493, at the age of 23; probably in Strasbourg. He returned to Nuremberg in 1494, when he married. Later, in 1494, he made his first trip to Venice, where he encountered at first-hand the Italian Renaissance, which had a tremendous effect upon him and his consequent development as an artist, and as a person. Most importantly for him, he encountered there a different attitude toward art and artists. In his native Germany, artists were still regarded—in the convention of the Middle Ages—as craftsmen, within the rigid order of the Nuremberg guilds. In Italy he found a philosophical and intellectual approach to art, which accorded with his own aspirations. This is the crux of the changing status of the artist at this period.

On his return home the following year, he made watercolor paintings of the landscape, which are very relevant to this painting. The next 10 years were incredibly productive and established his international reputation. During this period he painted the two remaining self-portraits: this one in 1498, when aged 26, and his last, Christ-like one in 1500 aged 29, by which time he was already famous and much sought after.

Fact

Dürer relished the social position accorded to artists in Italy and during his second visit to Venice he wrote in a letter of his reluctance to return to Nuremberg: "Here I am a lord, at home I am a parasite."

20 in (52 cm)

16 in (41 cm)

1500	1502	1505–07	1971
Third and last of his painted self-portraits, aged 29	Jacob Wimpfeling, in his handbook of German history, describes Dürer as the outstanding artist of his day	Returns to Venice for the second time	Dürer's quincentenary: Germanisches Nationalmuseum stages a comprehensive exhibition, attracting 360,000 visitors

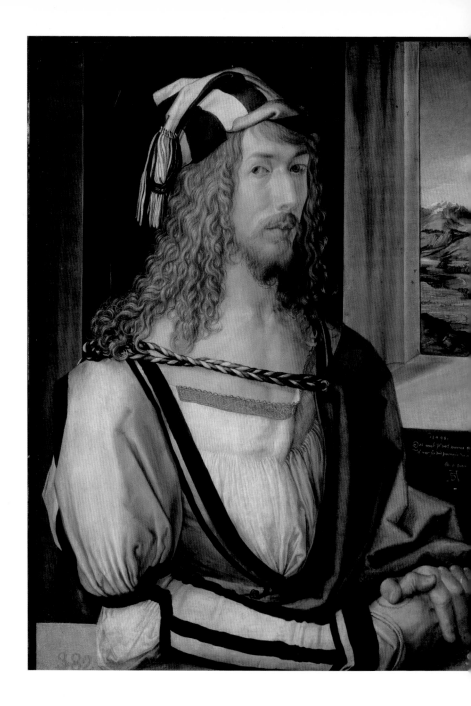

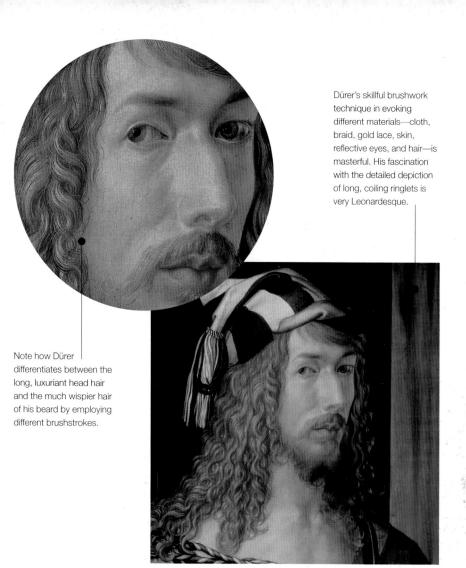

Dürer's skillful brushwork technique in evoking different materials—cloth, braid, gold lace, skin, reflective eyes, and hair—is masterful. His fascination with the detailed depiction of long, coiling ringlets is very Leonardesque.

Note how Dürer differentiates between the long, luxuriant head hair and the much wispier hair of his beard by employing different brushstrokes.

In his paintings, Dürer mainly used wooden panels coated with white chalk on which he would execute his preparatory drawing. The painting is then built up, layer by layer. To conserve his painting, he invented a special varnish that had to be applied after the wood panel had thoroughly dried out, which could take up to three years. The graphic quality of his work is clearly informed by his expertise in drawings and engravings. In Four Books of Human Proportion (1532), Joachim Camerarius relates how Bellini asked Dürer to present him with the brushes that he used to draw hair. Dürer produced the same brushes that Bellini had used and drew some wavy tresses, much to Bellini's amazement.

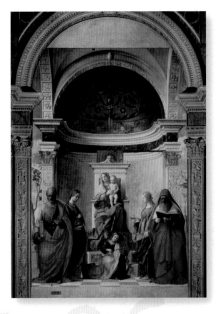

GIOVANNI BELLINI, c.1430–1516

Virgin and Child with Saints

1505, originally oil on panel (transferred to canvas)
S. Zaccharia, Venice

THE CAREER OF GIOVANNI BELLINI spanned much of the 15th century and the early years of the 16th century. He had the ability to operate in different styles and the capacity to absorb a wide range of influences—consequently over the course of a very long career, his style changed more than any other 15th-century painter. He was instrumental in transforming the Venetian school of painting from regional significance to preeminence within Italian Renaissance art, rivaling that of Florence and Rome. His father Jacopo and his brother Gentile were artists, and his sister Nicolasia married Mantegna.

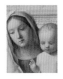

1459	1475	c.1480
Giovanni first documented as living in his own house in Venice	Antonello visits Venice and paints the *S. Cassiano Altarpiece*	Bellini paints the *S. Giobbe Altarpiece*, which clearly influenced this later version

Bellini's early works were in tempera but, after Antonello's *S. Cassiano Altarpiece*, he adopted the medium of oil and developed its expressive qualities in a way that impacted on subsequent painting techniques, thereby revolutionizing the art of painting.

Unlike the Florentine emphasis on disegno, the use of line and perspective, Venetian art used color to create form and to unify the various elements of the composition—color was not merely an adornment to be added after the picture had been drawn. The *S. Zaccaria Altarpiece* was one of a series of monumental *sacra conversazione* that Bellini produced over his career, which set precedents against which subsequent altarpieces throughout Italy were measured. He was already aged 75 when he painted this work, commissioned in memory of Pietro Cappello. It reflects a lifetime of experience and the culmination of his experiments in this genre. Like the *S. Cassiano Altarpiece* and his own *S. Giobbe Altarpiece* (c.1480), it shows the Madonna and Child enthroned among saints, seated beneath the apse of a chapel with the architectural illusion of extending the viewers' space into the picture. There are fewer figures than there are in the *S. Giobbe Altarpiece*, and the side walls are open to the outside, thus creating more space and light—a warm, mellow light that evokes an atmosphere of dreamy and gentle meditation. There is an air of distraction, of communal contemplation that is different from the previous works.

197 in (500 cm)

Fact

His actual birth date is unknown but, according to Vasari, Bellini was 90 when he died—this would give a birth date as early as 1425, though he may have been born as late as 1435. His pupils included Giorgione and Titian.

93 in (235 cm)

1480–1506	1490s	1577	1658
Albrecht Dürer, visiting Venice, writes that, despite his age, Bellini was still the best painter there	Huge demands for work by Bellini lead to the formation of one of the largest workshops in 15th-century Italy	Bellini's masterpieces for the Doge's Palace in Venice are destroyed by fire	Ridolfi describes this painting as one of the most beautiful and refined works of the master

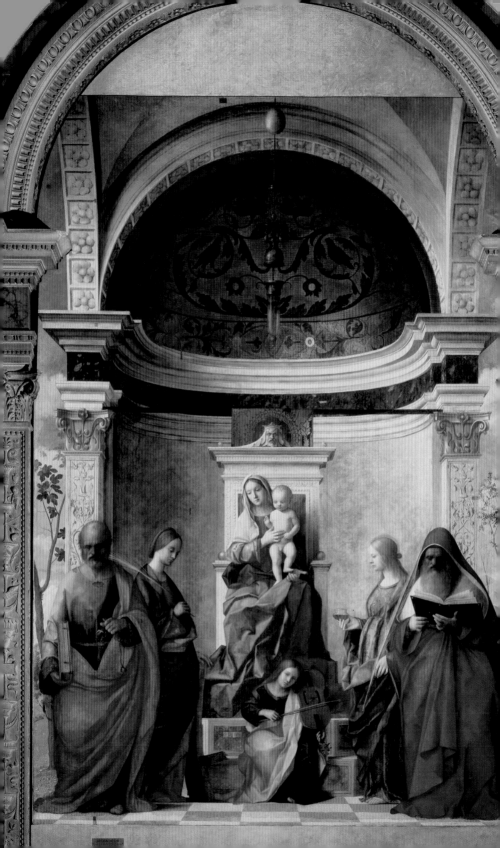

The composition is balanced and harmonious with the figures of the saints arranged in a semicircle, echoing the form of the apse in which they stand. At the feet of the Virgin sits an angel musician, thus completing the elliptical figural arrangement. The poses of the saints are symmetrical: the two male saints (Peter and Jerome) face the viewer, while the female saints (Catherine and Lucy) are turned toward the Virgin and Child. None of the figures looks at another: Jerome is engrossed in his bible, while the others are deeply reflective—even the Virgin and the Christ Child. Although the angel is looking outward, he does not engage our eye. The whole composition is one of dreamy abstraction—an otherworldly spirituality.

The brilliantly depicted architecture demonstrates Bellini's firm grasp of perspective—note how the painted architecture reflects the stone framing architecture.

The moody evocation of the stormy clouds in the natural world outside adds tension to the pervading atmosphere within.

The contemplative stillness of the figures and their serene abstraction evokes a sense of the eternal.

Over his long career, Bellini steadily refined his modeling to achieve increased subtlety and deeply enriched his colors, using oil glazes. His command of the oil medium is evident in the wider tonal ranges of his colors.

Red · Ultramarine · Green · White · Red lead · Yellow · Gray green

Bellini used broad swathes of softer, warmer, deeply saturated colors to build his figures. Thus the two male saints appear monumental and yet, at the same time, less solid. Their close tonal colors are echoed in the cloak of the angel, up through the dress of the Virgin to the gilded mosaic apse with its contrasting decoration of evergreen acanthus—an early Christian symbol. Similarly, Catherine's dark-green mantle contrasts with her own dress and that of Peter's cloak, while the outer curve of her body echoes his. High white colors emphasize the most important part of the picture—the Virgin and Child. A mellow, glowing light pervades the whole scene, both uniting the space and evoking a sense of timeless spirituality.

The sensuous mass of rich blue, green, and red in the Virgin's clothing is a magnificent chromatic display.

The virtuoso modeling of the Virgin's blue robe and its wide tonal range from deep dark to almost white, demonstrates Bellini's coloristic skills.

Bellini continually experimented with pictorial techniques and on extending the expressive range of the oil medium. Here he explores the relationship between color, light, and air with the result that the distinction between solid and space is hazy. There is less emphasis on contour lines and instead he merges the transition from light to shade. Thus light controls form. There is a shifting in and out of focus. The effect is to accentuate the focal figures of the Virgin and Child, who are sharp and clear. It also serves to heighten the dreamy, spiritual atmosphere and emphasizes the devotional, almost supernatural, aspect of this sacred space. This is reinforced by another technical trick—the high viewpoint, revealing the paved floor.

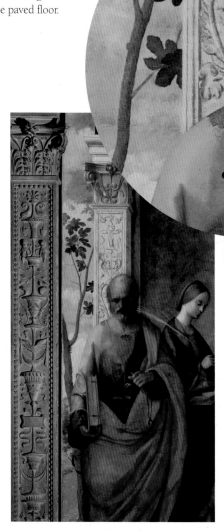

Spatial recession and the architectural articulation of pilasters, entablature, and arches, demonstrates a thorough understanding of Florentine perspective.

The merging of light and shade, solid and air, creates an effect similar to the *sfumato* of Leonardo: soft drapery and blurred heads. Note how Peter's face is out of focus and his right arm and shoulder seem to melt into the sky.

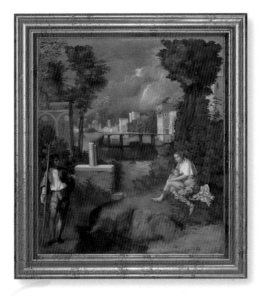

GIORGIONE, c.1477/78–1510

The Tempest

(unknown), oil on canvas, Accademia, Venice

IN HIS SHORT LIFE, GIORGIONE BARBARELLI REVOLUTIONIZED the art of painting and inaugurated the "painterly," color-based style of Venetian painting, which stood in opposition to the Florentine tradition. Although his oeuvre (the number of surviving paintings attributed to him) is extremely small, and still much debated, its impact was huge. By the time that he died of plague in 1510, his work was so highly prized that Isabella d'Este of Mantua was unable to acquire a single example.

Giorgione was a pupil of Giovanni Bellini, and toward the end of Bellini's long life he was influenced by the innovative style Giorgione developed. In

1530	1548	1800
Marcantonio Michiel reports seeing the painting in the house of Gabriele Vendramin	In *Dialogue on Painting*, the Venetian theorist Paolo Pino describes Giorgione's style as one of "poetic brevity"	Marcantonio Michiel's *Notizie* is republished—consequently *The Tempest* comes to public attention

turn, Giorgione taught Titian, who completed some works after his death so successfully that this has further complicated attribution.

Giorgione also introduced a new, secular subject matter that differed from the antique-inspired secular subjects of central Italy. In particular, his small, enigmatic and poetic paintings deliberately eschewed explicit narrative and symbolism, instead relying on creating a "mood." He adopted a novel approach to figures within a landscape, whereby the landscape is not mere background but integral to the picture. The focus is the link between humanity and nature; human emotion or action/inaction within an atmospheric landscape. Such works were intended for private collectors and tended to be mysterious and evocative, and difficult to interpret—even, or especially, now.

The first of these "landscapes of mood" is this enigmatic work of uncertain date. It is the most representative of the few genuine surviving works of Giorgione. The mystery of its meaning only increases its fascination. The picture was commissioned by Gabriele Vendramin, in whose house it was seen and noted by Marcantonio Michiel in 1530, and it is likely to have remained within the family until the end of the 18th century. The work is to some extent inspired by Bellini's figures in landscapes; for example, the use of a high viewpoint and the strong contrast between the figures and their background. It is also influenced by Leonardo, who visited Venice in 1500 and who had a profound effect upon Giorgione, most notably in the softening of form and in his interest in botanical and meteorological details.

Fact

Giorgione is no less mysterious than his paintings—so little is known about him. Vasari fueled the "myth of Giorgione" by describing him as a person of gentle and courteous manners, fond of social gatherings ... and whose love of a lady brought him to a premature grave.

32 in (82 cm)

29 in (73 cm)

c.1850	1875	1932	1984
The Tempest is mentioned as being in the Manfrin Collection, Venice	The painting is acquired by Prince Giovanelli for his palace in Venice	The piece is acquired from the Giovanelli family by the Accademia in Venice	*The Tempest* is at last restored

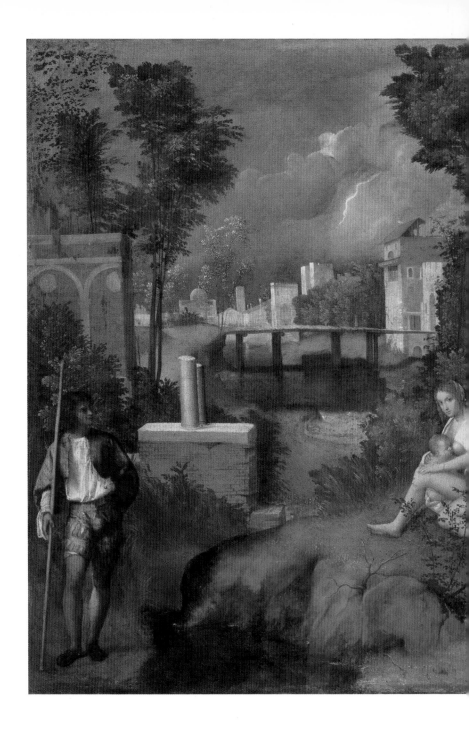

Giorgione's innovative technique must have led to alterations and corrections, which recent scientific research has demonstrated. For example, an X-radiograph has shown that the standing soldier has replaced a female nude seated by the river.

The lightning flash indicates the time frame—a split second. Tension is accentuated by the discordance between the light's direction and its apparent source.

The dominating feature of the painting is the storm-laden sky with that strange "otherworldly" light that precedes a thunderstorm. Giorgione was the first artist to paint a meteorologically correct storm. In the foreground are two strangely disconnected figures, who are brightly colored in strong contrast to the darker, brooding landscape. On the left a man, usually described as a soldier, leans on a staff looking directly toward the second figure—a naked woman nursing a child. Behind him are trees, vegetation, and ruins—the two broken pillars are highlighted and therefore seem important, though why is unknown. On the right the naked woman sits with her child, glancing directly at the viewer with a very knowing expression.

Giorgione's mature work is characterized by atmospheric and coloristic unity and, instead of contour, form is inferred through a painterly evocation of light and color. Dramatic quality is evoked by the juxtaposition of bright highlights and dark shading.

The last light of the fading moon/sun rimming the clouds, echoes the form of the lightning flash—he has captured the moment just as the one disappears and the other appears.

Green

Gray

White

Brown

The moment of vibrant brightness as the storm breaks is depicted by the fluid graduation of chromatic values achieved by modulating the tones of light and dark.

Blue

Yellow

A consequence of Leonardo's approach to lighting, color, and tone was that of tonal harmony, resulting in rather gloomy lighting and reduced color contrast. Contemporary Venetian painting showed no tendency toward quieter colors. Although Giorgione was impressed by Leonardo's *sfumato* effects, he achieved similar results by a different route. His work is far from "gloomy" and certainly does not lack color. The foreground consists of warm browns and red, set against a range of dark greens in the middle ground with emerald merging to turquoise in the background; and the whole is united by the all-embracing atmospheric light.

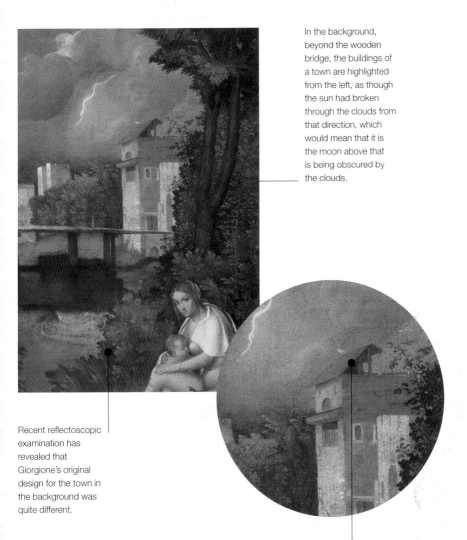

In the background, beyond the wooden bridge, the buildings of a town are highlighted from the left, as though the sun had broken through the clouds from that direction, which would mean that it is the moon above that is being obscured by the clouds.

Recent reflectoscopic examination has revealed that Giorgione's original design for the town in the background was quite different.

On the roof directly below the lightning flash and above the woman is a long-necked white bird—a stork would symbolize filial piety, and a crane would symbolize vigilance.

According to Vasari, Giorgione did not use preparatory drawings but painted directly with colors, working out his compositions as he proceeded. This was a technique later followed by Titian. Giorgione exploited the suggestive qualities of the oil paint medium, achieving the play of light on various surfaces by a painterly method, that is, by varying the way he applied the paint. He was not particularly concerned with accurate perspective recession or correct *disegno*, as evidenced by the somewhat clumsy articulation of the woman's body: her legs are awkwardly and unconvincingly positioned; the child is seated behind her right leg yet suckling from her left breast but her body is not twisted appropriately to accommodate this relationship. Such discordancy enhances the tension.

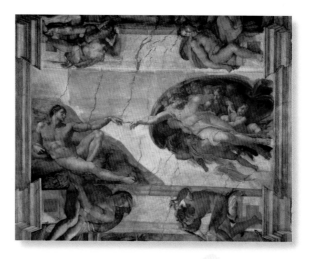

MICHELANGELO BUONARROTI, 1475–1564

The Creation of Adam

1508–10, fresco, Sistine Chapel ceiling, Rome

MICHELANGELO IS CELEBRATED AS THE GREATEST practitioner of the three visual arts of sculpture, painting, and architecture. He is one of the three major Renaissance artists, along with Leonardo da Vinci and Raphael. His father was a minor Florentine nobleman and opposed to his son taking an apprenticeship as a painter—this being regarded as manual work and therefore unfit for a gentleman. Michelangelo's own career did much to change the status of artists and the esteem in which they came to be held. He joined the workshop of Ghirlandaio in 1488 and not long afterward joined other sculptors at work in the Medici gardens, where he came to the notice of Lorenzo the Magnificent. Above all, he learned from drawings he made of the frescoes of Masaccio and Giotto.

1506	1508	1510
Project for painting the Sistine ceiling under discussion	Michelangelo signs a contract to paint the vault	With most of the ceiling completed, work halts

In the spring of 1508 he was summoned to Rome by Pope Julius II to paint the frescoes for the Sistine ceiling. Most of the work was completed by 1510, when there was a long break—Julius was in Bologna and money was short. Work resumed in 1511 and was completed by 1512. During the period that work was halted, there was an official unveiling on August 15, 1511. The final unveiling took place on October 31, 1512. It was immediately acclaimed as a supreme masterpiece and Michelangelo as the greatest artist of his time—thereby raising the prestige of the practitioner of art.

The ceiling of the Sistine Chapel is a shallow vault, approximately 115 x 46 ft / 35 x 14 m. Below, on the side walls of the chapel, are the frescoes painted in the 1480s, which represent the life of Moses and the life of Christ. It was important that the ceiling program harmonized with the earlier frescoes—along the center of the ceiling are nine narratives from the Book of Genesis: the first three, near the altar, show the creation of heaven and earth; next is the creation of Adam and then of Eve; the fall of man and the expulsion from paradise are followed by three narratives of Noah, ending with his fall into sin, near the entrance to the chapel. Thus the scenes are intended to be read from the altar to the door, though in fact they were painted in reverse order, starting with the door.

150 in (380 cm)

Fact

A story tells how the unkempt Michelangelo was out walking when he saw a large group of gaily-clad people approaching. When he realized it was Raphael he called out: "Ah, I thought you were a judge on circuit with his entourage." To which Raphael quipped: "And we thought you were the hangman!"

224 in (570 cm)

1511	1512	1536	1541
August: First official unveiling of the painting	October: Work completed, and official unveiling of the completed ceiling	Begins painting *The Last Judgment* on the altar wall of the Sistine Chapel	*The Last Judgment* is officially unveiled, exactly 29 years after the unveiling of the ceiling

This is one of the larger narratives, toward the center of the Sistine Chapel ceiling. Just visible, on either side, is the fictive cornice that defines the central area along the length of the ceiling. Running across the ceiling are five pairs of fictive "ribs," which frame the upper and lower edges of each scene. At the junction of each rib with the cornice is a painted pedestal on which sits a naked youth. These youths are the *ignudi*, and their significance is uncertain, although they possibly represent the Neoplatonic ideal of humanity. Within this architectural framework, on the left, reclines the magnificent, languorous, and naked body of Adam, barely able to lift his hand toward the powerful and majestic figure of God, reaching out to impart the spark of life. The small gap between the fingertips is magnified by the stark gap between the figures with nothing in the background to detract the eye—it is thus clearly visible from the floor.

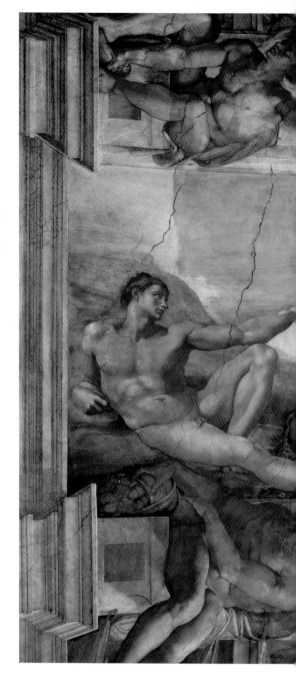

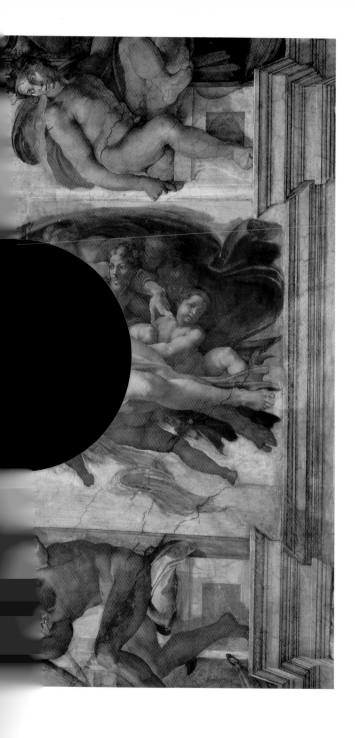

As Giorgione was the proponent of *colore*, so Michelangelo epitomized *disegno*. Although Michelangelo used a little gilding in the earlier sections of the ceiling, he did not use it here. Gilding and bright colors provide visual interest on the surface of a painting but counteract the sense of recession, of the dissolution of the surface, which is what Michelangelo was aiming for here. Thus he uses homogenous colors and modulates their tones. He uses very few colors and there is a deliberate absence of bright pigments—even the sky and earth are reduced to smudges of blue, and green/brown respectively. (Michelangelo was not keen on aerial perspective.) The emphasis is on space, the cosmos, and the psychological gap between Man and God.

White
Green
Blue
Red
Black
Gray

The period shows increasing interest in the suggestive rather than the definite mode of representation, with subtle modulations of light and dark rather than hard edges. Michelangelo, however, did not use this technique very much in his painting.

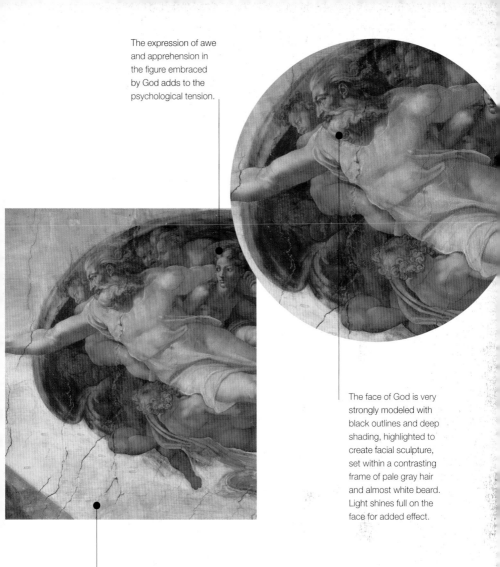

The expression of awe and apprehension in the figure embraced by God adds to the psychological tension.

The face of God is very strongly modeled with black outlines and deep shading, highlighted to create facial sculpture, set within a contrasting frame of pale gray hair and almost white beard. Light shines full on the face for added effect.

The virtuoso depiction of *contraposto* figures and foreshortening of limbs and arms earned Michelangelo the reputation of being the chief exemplar of *disegno*.

For mural painting Michelangelo favored *buon fresco*, which required rapid execution. He used the traditional methods of sketches and cartoons that left little room for spontaneity. Despite the brilliance of his brushwork his representational technique relied on controlled use of outline and internal modeling. He uses a range of illusionistic techniques to create the effect that we see—God creating Adam through a window in the ceiling, as though God were floating in the cosmos above us. The framing fictive architecture, inventive use of foreshortening to adjust for viewing from the ground, informed anatomical detail of the nude figures, and homogeneity of color tone, all give a sense of depth and add to the illusion.

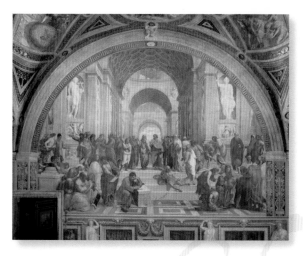

RAPHAEL, c.1483–1520

The School of Athens

c.1509–12, fresco, Stanza della Segnatura, Vatican, Rome

RAPHAEL, BORN RAFFAELLO SANZIO OR SANTI, was the youngest of the three great artists credited with creating the style described as High Renaissance. Raphael was born in Urbino, where his father was employed as the court artist to the Duke, Guidobaldo da Montefeltro, whose court was renowned throughout Italy as a center for the arts. He was trained by Perugino, whose sweet and graceful style had a profound influence on him.

In 1504 he arrived in Florence, where he spent the next four years familiarizing himself with the new Florentine style, particularly the works of Leonardo and Michelangelo, whose "battle" cartoons (*Anghiara* and *Cascina*, respectively) were on show in the Palazzo della Signoria. In 1508 he was summoned to Rome by Pope Julius II to help with the decoration of the pope's apartments but he soon

1508	c.1509–12	1512–13
Raphael summoned to Rome by Pope Julius II	Painting of the Stanza della Segnatura	Paints the entrance arch of the Chigi Chapel in S. Maria del Popolo with "Michelangelesque" sibyls

became the principal artist on the scheme. Despite the fact that at this time he had little experience of fresco painting, he was awarded the commission to paint the Stanza della Segnatura, which was so successful that he was consequently commissioned to paint the remaining Stanze: the Stanza d'Eliodor (1512–14) and the Stanza dell'Incendio (1514–17). Work on the Stanza della Segnatura (the pope's library) probably began in 1509. The room is 32.8 x 26.2 ft / 10 x 8 m with a cross vault and, with shelving around the walls, the main space for painting was the lunettes, pendentives, and the ceiling.

The intellectual program for this work is extremely complex but basically it was dedicated to the four branches of knowledge: poetry, philosophy, theology, and jurisprudence. Thus the function of the room is reflected in the subjects of the frescoes. The *Disputa* was the first to be painted and opposite it is *The School of Athens*—these are the two largest lunettes and represent Theology and Philosophy, respectively. Balanced, serene, calm, and classically posed, they are the best examples of High Renaissance art. The remaining two smaller lunettes are the *Virtues* and *Parnassus*. Raphael's genius lies in finding simple pictorial means to convey these abstract concepts. In these frescoes he demonstrates his mastery of perfect design and balanced composition. By 1514 he was the supreme artist of Rome, rivaled only by Michelangelo, who was already at work on the Sistine ceiling when Raphael arrived in Rome. For two to three years, these two great artists were creating their masterpieces within the same building and for the same patron.

Fact

The High Renaissance is characterized by harmony, symmetry, and an understanding and appreciation of classical antiquity. The best artists demonstrated a control and mastery of their techniques, enabling them to achieve true representations.

303 in (770 cm)

c.1512–14	c.1514–17	c.1515	1520
Painting of the Stanza d'Eliodora	Painting of the Stanza dell'Incendio	Raphael made 10 polychrome cartoons for tapestries to decorate the lower walls of the Sistine Chapel	On Good Friday 6 April, Raphael died suddenly. His last painting, *The Transfiguration*, was set at the head of his bier

The School of Athens is set within a magnificent classical building, which may have been based on Bramante's plans for St. Peter's (Bramante was a friend and kinsman). At the very center of the composition, framed by coffered arches, stand two men in discussion: the one on the left, pointing upward, is Plato holding his *Timaeus*; the one on the right is Aristotle with his *Ethics*. Around them a group of men are listening to the debate. To the left, in green, stands Socrates leading another debate. In the foreground, the group on the left includes Pythagoras writing, while a young boy shows him a board with a diagram of his harmonic theory. Opposite them on the right, Euclid bends over a slate with compasses, explaining a geometrical theorem. This is thought to be a portrait of Bramante. Behind him are Ptolemy and Zoroaster holding globes and, next to them, peeping out at us, is a self-portrait of Raphael. The brooding figure of Heraclitus at the front of the scene is a portrait of Michelangelo.

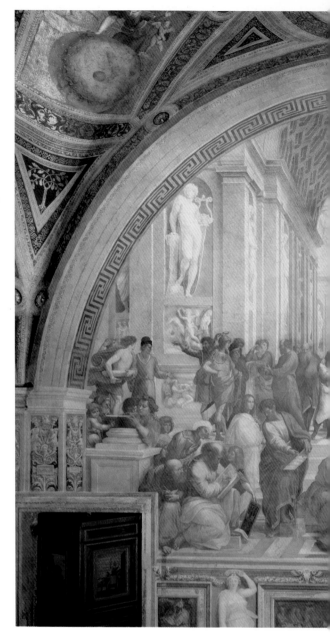

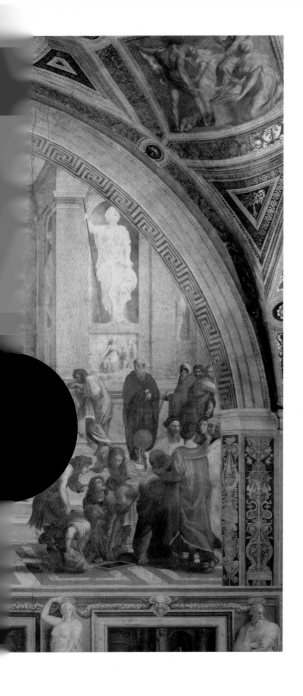

Raphael uses a wide range of colors but avoids abrupt color contrasts. By changing tone and color he gives his composition variety and interest. He is clearly interested in color and uses it intelligently to clarify and harmonize the various elements of his composition, which otherwise could be difficult to perceive. Thus his central group include brightly clad robes flanked on each side by a figure in green with a white cloak. His other groups have colors that harmonize, allowing us to differentiate between them; for example, for the group on the right he has used muted shades of earth colors, mainly green.

Orange

Red lead

Mauve

Blue

Red

Yellow

Green

In the left-hand group, pastel shades predominate; in the group behind and above, greens and blues. These both differentiate and act as a spatial indicator.

For most of his career, Raphael tended to use warm and radiant colors, which is something he learned from Perugino and which, in this regard, allies him more with Venetian artists than with Michelangelo or Leonardo.

Raphael also "bends the rules" by making Plato and Aristotle larger than they should be, given their central placement above the flight of steps, which indicates their importance. If drawn to scale, given their distance, we wouldn't see them clearly.

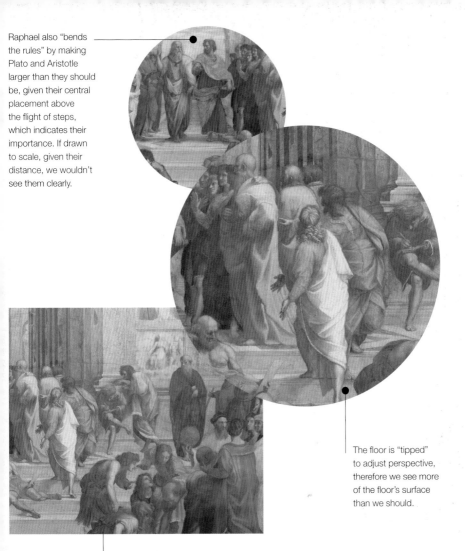

The floor is "tipped" to adjust perspective, therefore we see more of the floor's surface than we should.

Raphael demonstrates his skill at portraying the human body by giving his figures complex and varied poses.

For the lunettes, Raphael has adopted the same "window in the wall" convention that Michelangelo used on the Sistine ceiling but here adjustment of perspective is required to sustain the illusion. We see more of the floor than we should, given that the mural is above eye-level. This is necessary because Raphael wants to show different schools of philosophers and therefore the spatial relationship between the groups needs to be clarified. He does this by exploiting the convention of the checkered floor and steps to display the relative positions of his figures in relation to the squares and steps. Dispersing figures around the steps also lets him show more figures with greater clarity, rather than crowding them into the foreground.

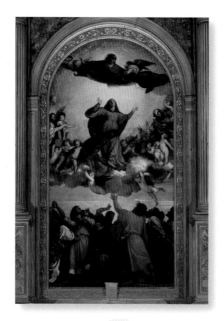

TITIAN, c.1485–1576

The Assumption of the Virgin

1516–18, oil on panel, S. Maria Gloriosa dei Frari, Venice

BORN TIZIANO VECELLIO, TITIAN WAS BROUGHT TO VENICE as a child and trained under Giovanni Bellini and, later, Giorgione. With the early death of Giorgione in 1510, and Bellini in 1516, Titian reigned supreme as Venice's premier artist. He was immensely successful in his lifetime and excelled in all branches of painting: religious, portraits, allegories, mythologies, and history. He has become recognized as the founder of the "painterly" style of Venetian painting, his handling of paint equaling Michelangelo's mastery of draftsmanship. In 1548, Vasari characterized this opposition as "the *disegno* of Michelangelo and the *colorito* of Titian."

1516	1518	1533
Altarpiece commissioned for S.Maria Gloriosa dei Frari, Venice, dedicated to the glory of the Virgin	The public is admitted to admire the painting	Titian ennobled by Emperor Charles V and appointed court painter

While the methodology of central Italian painters involved much forward planning—draftsmanship, perspective, and preliminary drawings—in Venice the emphasis was on the process of creation. Titian, for example, was much more improvisatory and sometimes didn't use a brush at all. Composition is controlled by color. A further attribute is that Venetian painting excelled in representing the "delicate" body—while Michelangelo championed the male body, Titian excelled in the female body.

Titian's first large religious commission, which established him as the heir to Giovanni Bellini, was by the Franciscan order for *The Assumption of the Virgin* for the high altar of S. Maria Gloriosa dei Frari in Venice. It was commissioned in 1516 and consecrated on March 20, 1518. In order to appreciate Titian's design, we need to take into account the siting of the painting and, therefore, the conditions for viewing it. The Frari is a very large church with central nave and aisles divided by 12 massive pillars. About two-thirds along there is a marble screen across the nave, which encloses the choir. In the center is a semicircular arch through which the high altar is viewed. The altarpiece is set within a semicircular marble frame, which mirrors that of the screen arch. Since the congregation would be restricted to the area between the door and the screen, the painting needed to be clearly visible at a distance and impressive enough to be worthy of its position. The altarpiece is, indeed, extremely large at 272 x 142 in / 690 x 360 cm.

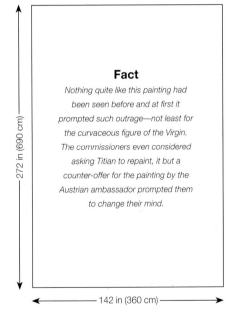

Fact

Nothing quite like this painting had been seen before and at first it prompted such outrage—not least for the curvaceous figure of the Virgin. The commissioners even considered asking Titian to repaint, it but a counter-offer for the painting by the Austrian ambassador prompted them to change their mind.

272 in (690 cm)

142 in (360 cm)

1545	1557	1576	1664
Titian makes his only visit to Rome, and meets Michelangelo	Lodovico Dolce writes, "To Titian alone is due the glory for perfect coloring…"	Titian's final painting is another altarpiece, the *Pieta*, probably intended for his own funerary chapel	Palma Giovane, a pupil, reports: "when finishing, he painted much more with his fingers than with his brush"

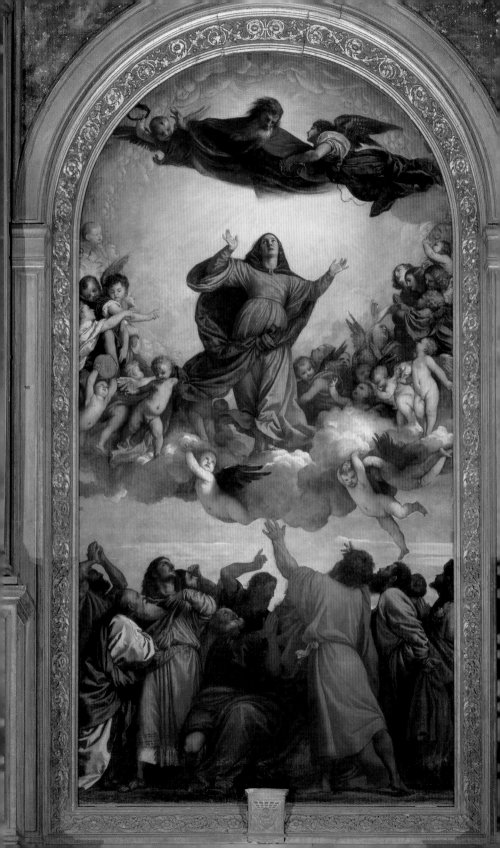

For viewers in the choir, the impression is that the action is taking place in an extension of their own space.

The group of apostles crowded onto the foreground enhances the impression of an event taking place immediately—increasing the sense of drama.

The suggestion here is that the viewer is actually watching the drama taking place through a window in the wall. The figures are organized in a tripartite division with the apostles and Mary forming one triangle, and Mary and God another. The angels ranged along either side demarcate the celestial from the earthly domains. Thus a scene of many figures is structured into an easily read composition. This is a religious episode presented as a human drama—the Virgin is taken by surprise, as are the apostles. The timeframe is immediate—this is happening now, which is very different from the traditional treatment of this theme: symbolic, hieratic, predestined. This is what was so revolutionary and so disquieting to a contemporary audience.

Blue
White
Yellow
Red
Green

Subtle variations of red are used in areas adjacent to harmonize with the main blocks of color, helping to unify the design.

Different shades of red serve to differentiate—the red used for the apostle on the right is a deeper tone than that used for Mary.

Titian makes careful use of color to express meaning, characterization, and mood. He might use dark, muted tones, highlighted in places, to draw one's attention to particular details. Alternatively, he might use harmony of color to give a sense of psychological harmony, or brilliant color contrasts to express violence.

In order to focus attention on the figure of Mary, her figure is silhouetted against an aura of bright, luminous light, to which the eye is naturally drawn. This effect is enhanced by the bright red of her robe, and by her face and outstretched hands, which are highlighted with a golden light from the radiance emanating from God. This ensures that she is the most brightly colored figure in a potentially "busy" design. Color is also used to impose structure and unity on the design—thus the red of her robe is echoed by the robes of two apostles below her, emphasizing the triangular composition; it is also picked up at the apex in God's cloak, contributing definition to the tripartite layering.

Titian has deliberately set the scene against an abstract background. No landscape or background details means an absence of perspectival devices to create the illusion of pictorial space, or to draw the eye in to a vanishing point—there is none. The effect throws into relief the action in the foreground and enhances the drama. Instead, to aid clarity, as well as the organization of figures and use of color, Titian has manipulated the foreshortening of the figures. The apostles are much more foreshortened

Fast, free handling of the paint and loose brushwork in places enhances the dynamism and transitory nature of the scene that Titian wished to achieve. Lack of preparatory drawings, and even underdrawings, in other paintings examined indicates that he was prepared to improvise.

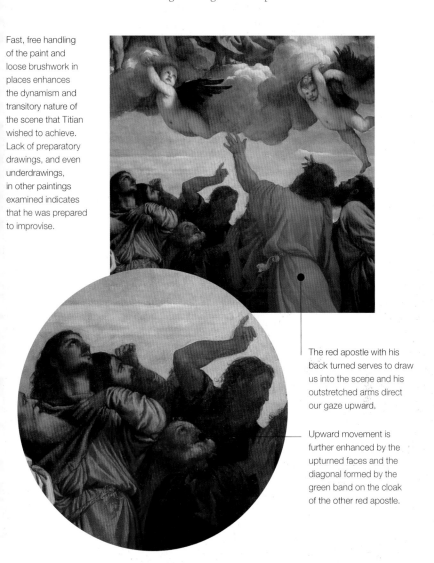

The red apostle with his back turned serves to draw us into the scene and his outstretched arms direct our gaze upward.

Upward movement is further enhanced by the upturned faces and the diagonal formed by the green band on the cloak of the other red apostle.

than is necessary, so that we seem to be looking up at them, while the figure of Mary is not foreshortened enough. If the same viewpoint were applied, we would not see much more than the underside of Mary's chin.

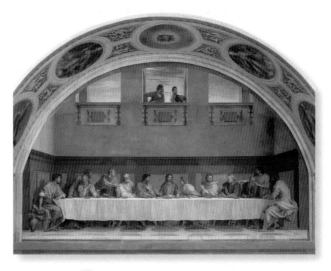

ANDREA DEL SARTO, 1486–1530

The Last Supper
1526–27, fresco, S. Salvi, Florence

WHILE MICHELANGELO AND RAPHAEL WERE ACTIVE IN ROME, Andrea became the leading painter in Florence. He was trained by Piero di Cosimo, who was a strong influence on his early paintings, along with Fra Bartolomeo. Later, and increasingly, he was influenced by Leonardo, in using *sfumato* to enrich his colors, and Michelangelo, for the monumentality of his figures; also Raphael and Ghirlandaio. He is known to have used engravings by Dürer, adapting the figures to his own style.

Andrea was highly regarded by his fellow artists and hugely influential on the next generation of painters—the most important serving in his workshop. He may be regarded as the initiator of Mannerism, given that his pupils included

1511	1511	1518–19
Andrea is commissioned to paint the refectory of S. Salvi, Florence	Andrea travels to Rome	Andrea is invited by Francis I of France to be court painter

Pontormo, Rosso, and Vasari. By exploring still further the animated, sensuous, and realistic tendencies of the first decade of the 16th century, he produced work that was vibrant, expressive, and communicative. His pupils then took this further, developing a style of agitated unease. More directly, Andrea's own works of the 1520s were adopted as models for the more naturalistic Tuscan artists of the Counter-Reformation.

His working process, which involved making a series of preparatory drawings for each of his paintings, became a model for the artists of the 16th century. Furthermore, a significant number of these drawings have survived. He was, in fact, the most influential and copied of Tuscan artists.

In 1511, Andrea was commissioned by the Vallombrosan monks at S. Salvi in Florence to paint a fresco on the end wall of their refectory. Beneath the large arch that frames the wall he painted the *Trinity* and the four protector saints of the order. However, the intended painting of *The Last Supper* was deferred, due to internal problems at the monastery. Instead, Andrea traveled to Rome that year. On his return he formed a group of artists who became known as the *avant garde* of Florentine painting and were referred to as the SS Annunziata school.

In 1518, Andrea was invited to France as court painter to Francis I. After his return in 1519, his style had changed and during the 1520s he produced works of monumental quality, including the spectacular *The Last Supper*.

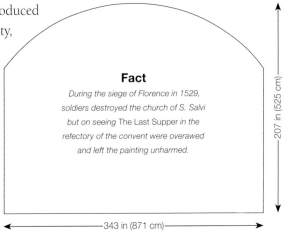

Fact

During the siege of Florence in 1529, soldiers destroyed the church of S. Salvi but on seeing The Last Supper *in the refectory of the convent were overawed and left the painting unharmed.*

207 in (525 cm)

——343 in (871 cm)——

1526–27	1529	1530	1568
Andrea paints *The Last Supper* for S. Salvi	*The Last Supper* escapes destruction during the siege of Florence	Andrea dies of the plague, brought to Florence by the besieging army	Speaking of this work, Vasari says, "I do not know how to praise his Last Supper without saying too little"

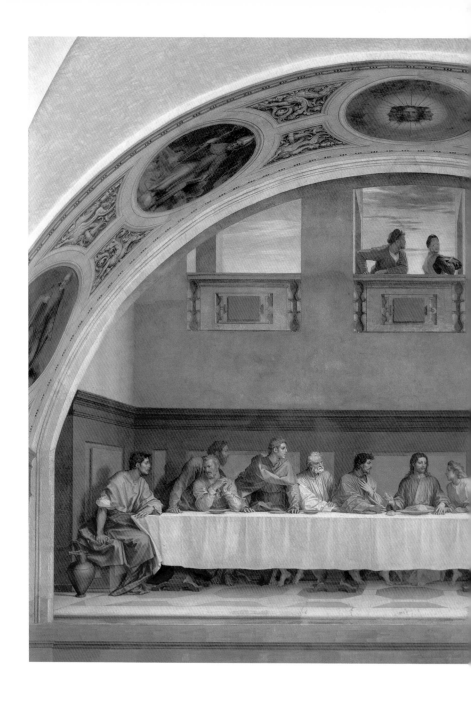

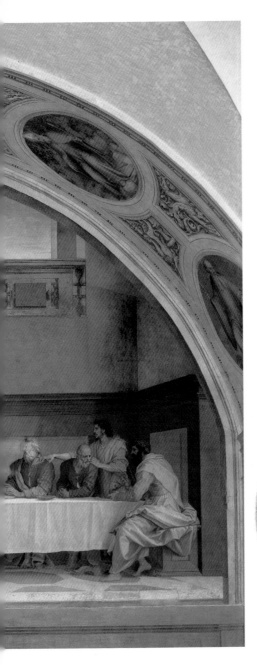

The fresco is placed under the large arch that frames the end wall of the refectory, which he had painted in 1511. The painted room appears to be an extension of the refectory—like a side-room. The geometrically patterned floor and the paneling on the back wall provide clear spatial references for the placement of the figures, which are arranged across the field of the painting as in a frieze. There is a clear dependence on Leonardo's *The Last Supper* (c.1494–98) painted for the convent refectory of S. Maria delle Grazie in Milan. As in that painting, and unlike previous examples of the subject, Judas is seated among the apostles on the same side of the table. Unlike Leonardo's version, however, Judas is actually seated next to Christ. Gestures and poses are less dramatic and more subtle; instead the bright luminous light clearly shows facial expressions, focusing on psychological rather than physical reactions.

The figures are placed in a rhythmic and balanced arrangement: Christ is flanked either side by two single figures, then a group of three with a figure at either end in a mirrored pose, like brackets enclosing the arrangement.

Andrea had a greater appreciation of color and tone than any of his contemporaries south of Venice and was the first Florentine to use shades of color to create composition. He favored a soft luminous palette.

Red Purple Mauve Gray

White Yellow Green

Andrea's superb coloristic sensibility is magnificently demonstrated in this fresco. He uses subtle colors, which are blended harmoniously with graduated tonal ranges that soothe the eye and create a meditative mood of classical restraint. Tone and intensity are used to create shadows, volume, and space. The luminous light flooding from the right highlights faces and folds of drapery and shimmering materials. Shadows cast on the walls emphasize space, so that the light seems to surround and embrace the figures. Colors are used to create rhythm and patterning, and to unify the composition. The coral-red is present in both the end figures and in Christ, and is picked up in certain figures in-between in different shades; it is also present in the floor and in the figure above at the balcony.

The darker-colored purple moldings of the lower wall embrace the seated figures, uniting the composition. They are echoed in the balcony panels and the sky. This is picked up again in the panels on the balconies above and at the apex in the sky.

The almost "Venetian" splendor of this figure is created by modeling apricot and coral pigments with white, to produce tonal ranges that suggest volume and form.

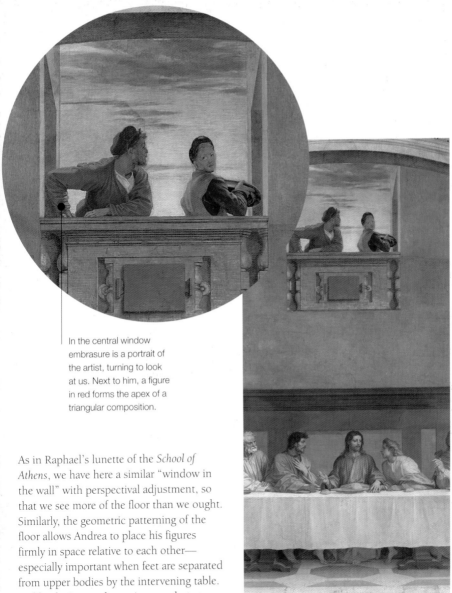

In the central window embrasure is a portrait of the artist, turning to look at us. Next to him, a figure in red forms the apex of a triangular composition.

As in Raphael's lunette of the *School of Athens*, we have here a similar "window in the wall" with perspectival adjustment, so that we see more of the floor than we ought. Similarly, the geometric patterning of the floor allows Andrea to place his figures firmly in space relative to each other— especially important when feet are separated from upper bodies by the intervening table. Unlike the Leonardo version, we do not see the ceiling of the room, thereby avoiding the "tunnel" effect. Instead the notional viewing point is as if we were standing just outside the room directly in front of Christ. As in Leonardo's version, although Christ is placed in the foreground, he occupies the vanishing point, which accentuates the focus on him.

By tracing the orthogonals— straight lines that recede into the picture space, like the horizontal edges of the wall moldings or lines on the floor—the vanishing point is located over Christ's heart.

TINTORETTO, 1519–94

St. Mark Rescues a Slave

1542–48, oil on canvas, Scuola Grande di S. Marco, Venice

KNOWN AS JACOPO ROBUSTI, TINTORETTO'S NICKNAME refers to his father's profession of cloth-dyer, an artisan who did not enjoy higher citizen status. Little is known of Tintoretto's early training—he may briefly have been apprenticed to Titian. By 1539 he was practicing as an independent artist, but recognition came slowly. He did not attract aristocratic patronage, which limited his commissions and thus his earning potential. As a consequence he adopted a policy of low pricing, rapid production, and increased output, which earned him much criticism and resentment from his contemporaries.

In the campaigns by people like Vasari and Federico Zuccaro, to raise the social status of artists, Tintoretto was regarded as an obstacle to this process. He was also accused, on more than one occasion, of "dirty tricks" to obtain a

1539	1548	1549
Tintoretto practicing as an independent artist	Tintoretto's reputation is established with the painting of *St. Mark Rescues a Slave*	In *St. Roch Healing the Plague Victims,* for the rival *scuola* di S. Rocco, Tintoretto uses *chiascuro* for the first time

commission. Ultimately he succeeded in establishing a large workshop offering quick turnover at competitive prices, due to his rapid method of execution and large numbers of assistants, which included his three children: Domenico, Marco, and Marietta. His patrons were mainly middle-class and most of his religious paintings were commissioned by the Venetian confraternities. In 1566 he was invited to join the Florentine Academy and from then until his death in 1594 he dominated Venetian painting along with Veronese and Palma Giovane.

The turning-point in his career appears to have been this painting, *St. Mark Rescues a Slave*, commissioned by the Scuola Grande di S. Marco. The painting caused a tremendous sensation in Venice at the time due to the unprecedented nature of its imagery, and initially was rejected and returned. Eventually, however, it brought him widespread recognition and established his reputation. It initiated the beginning of a more dramatic style of Mannerism than heretofore by such artists as Andrea Schiavone. The development in his own style can be seen by comparing this painting with a much later one on a similar topic, for the same *scuola*: *St. Mark Saving a Saracen*. There is less concern with spatial integrity and more violent drama, while the technique is more suggestive and abbreviated.

163 in (415 cm)

Fact

No-one could be so lacking in understanding of drawing as to fail to wonder at the relief of the figure, all nude on the ground, who is being subjected to the cruelty of martyrdom. (Aretino, 1548)

213 in (541 cm)

1562–65	1565	1566	1568
Paints *St. Mark Saving a Saracen* for the Sculoa di S. Marco, which demonstrates how his style developed	Becomes a member of the important *scuola* of S. Roco and is commissioned to decorate the large halls	Invited to join the Florentine Academy, which reflects his status at this time	Vasari describes Tintoretto as: "the most extraordinary brain that the art of painting has ever produced..."

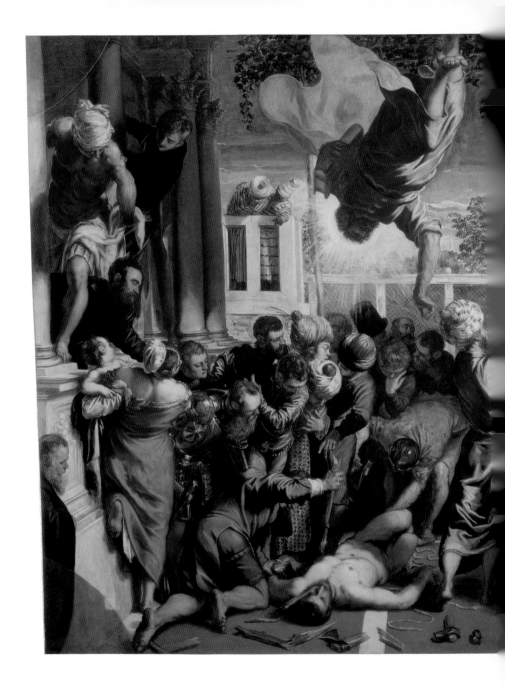

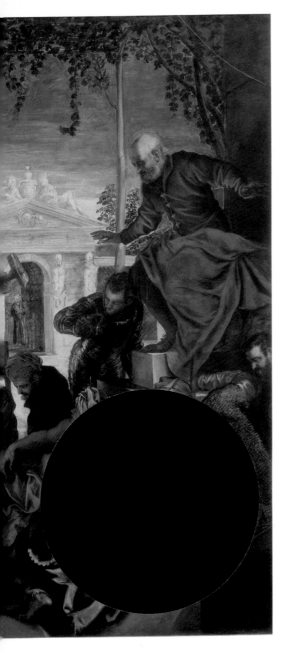

This large and crowded composition portrays the story of the miracle of St. Mark freeing the servant of a knight from Provence who had disobeyed his master by visiting the shrine of St. Mark in Lyon. The punishment decreed for this transgression by the knight, seated on a dais to the right, was blinding and mutilation. The body of the slave is laid out on the ground in the center of the composition, surrounded by onlookers, while one man prepares to thrust a wooden stake through his eye and another displays the instruments of torture. *Just at that moment*, the figure of St. Mark is depicted swooping in from above to save the doomed man. The figures placed on the foreground contrast with the horizontal serenity of the classical architecture in the background, enclosing a peaceful garden—there are even two figures in the gateway calmly unaware of what is taking place close by. The effect is to heighten the tension and drama of the foreground events.

The foreground is characterized by brash contrasts of brilliant coloring and violent contrasts of chiascuro, which serve to amplify the dramatic and emotional impact. This arresting mix of bright, clashing colors—orange-gold of the woman's dress; rich, deep blues of the torturer's costume; recurring flashes of red on the soldier's leg, which recurs in other parts of the composition—is broken by the white body of the slave. The eye is led along his highlighted right arm to the highlighted left foot of the green-clad figure in the middle, who makes an emphatic contrast against the warmer colors. His arms lead to the green of the garden in the background, while the pink topknot on his turban links to St. Mark's robe of the same color.

Shades of reds and golds predominate. In the middle of all these rich, deep colors, the luminous white body of the slave virtually glows and immediately draws the eye, aided by the device of a white strip.

Black White
Orange Blue

Green
Red

Tintoretto tended to alter his style according to the type of picture and the patron, so expensive pigments, like ultramarine, were used extensively only in works for aristocratic patrons. More generally, glowing reds and gold colors replace earlier, cooler colors.

The contrast in textures evoked by glittering helmet, solid mallet and splintered stake against the vulnerable white flesh of the slave serves to heighten the tension

Due to the figures crowded onto the front of the picture and the high viewpoint, the scene is depicted as though we were present, gazing down at the vulnerable body of the slave. Michelangelo was a formative influence, as evidenced by the expertly foreshortened figure of the slave that acts as the focal point for the picture. It is a supreme example of draftsmanship. Monumental figures and extreme foreshortening add to the narrative intensity. This is enhanced by, and mirrors, Tintoretto's "swift, abbreviated" style that involves a loosening of form and a certain roughness of technique. The extreme agitation of the crowd with twisted poses and exaggerated gestures adds to the immediacy of the event and draws us in. Tintoretto reportedly used models of wax and clay to arrange his figures and to achieve his compositions, rather than preliminary drawings.

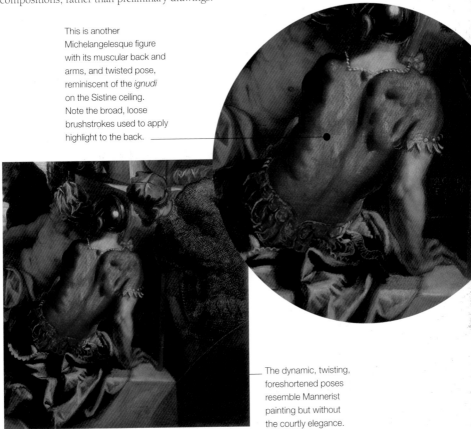

This is another Michelangelesque figure with its muscular back and arms, and twisted pose, reminiscent of the *ignudi* on the Sistine ceiling. Note the broad, loose brushstrokes used to apply highlight to the back.

The dynamic, twisting, foreshortened poses resemble Mannerist painting but without the courtly elegance.

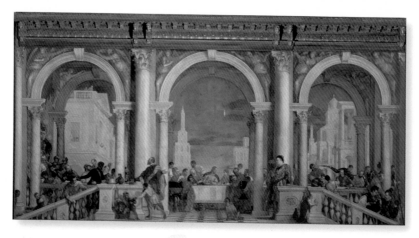

VERONESE, 1528–88

Feast in the House of Levi

1573, oil on canvas, S. Giovanni e Paolo, Venice

BORN PAOLO CALIARI, IN VERONA, VERONESE'S father was a sculptor. He was trained by a local painter Antonio Badile, from whom he learned the use of the cool, silvery colors and soft yellows that he used throughout his career. Later he trained with Gian Francesco Caroto. As a Roman town and site of antiquarian studies, Verona offered opportunities to study Roman architecture and illusionistic wall decoration that became such an important part of Veronese's oeuvre. By 1553 he had established himself in Venice and was already popular.

In 1560 he visited Rome, where again he had the opportunity to study antique architecture and also antique villa decoration, which he put to use on his return when he collaborated with Andrea Palladio on the decoration of the Villa Barbaro at Maser. The illusionistic paintings extended the architecture

1562–63	1572	1573
Veronese paints the first in a series of large, religious feast scenes	Veronese paints *The Banquet of Gregory the Great* for the shrine at Monte Berico, Vicenza	Paints *Feast in the House of Levi*, originally intended to be a *Last Supper*

of the rooms and included views of ruins, with details such as servants, pets, and children. This was formative in his later paintings of religious feasts, such as this one. In 1562–63 he painted the vast *Marriage Feast at Cana* with its crowded composition, grand architecture, and high viewpoint, reminiscent of Raphael's *Stanze*. There followed a series of paintings that serve as a link between that and *Feast in the House of Levi*, which was the last in the series of banqueting paintings. *The Banquet of Gregory the Great* (1572) has many aspects of composition that reappear in *Feast in the House of Levi*.

Feast in the House of Levi was originally commissioned for the refectory of SS Giovanni e Paolo as a *Last Supper* to replace the one by Titian, which had been destroyed by fire in 1571. However, the painting attracted the attention of the Inquisition, who took exception to its indecorousness and profanity, and were suspicious that the presence of two Germans seated next to Christ concealed a secret Lutheran message. Veronese was summoned to appear before a tribunal on July 28, 1573, where he repudiated the charge of indecorum and stoutly asserted the absolute right of artistic freedom. Nonetheless, he was ordered to amend the composition but refused to comply and changed the title instead.

219 in (555 cm)

Fact

Veronese's testimony before the Inquisition demonstrates the integrity of his artistic principles and his standing as a man of faith. It remains as the classic defense of the artist against the "Philistine."

504 in (1280 cm)

1573

Veronese is summoned to appear before a tribunal of the Inquisition to answer charges of profanity and indecorum

1588

Veronese dies after catching cold in an Eastertide procession

1815

Feast in the House of Levi is acquired by the Accademia, Venice

1979–83

Restoration removes the extensive repainting carried out in the 19th century

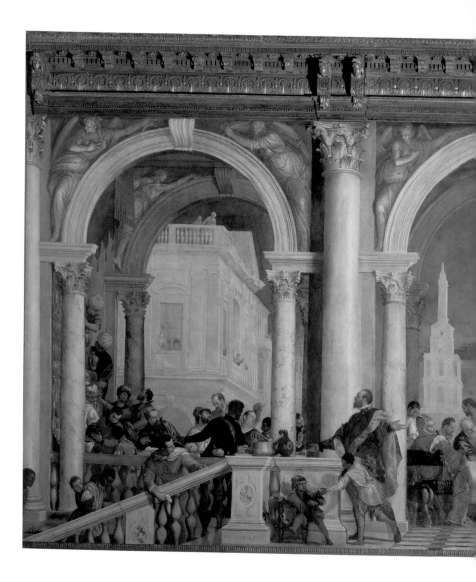

This huge picture (219 x 504 in / 555 x 1280 cm) epitomizes the art of the Venetian Renaissance with its use of classical architecture, deep perspective, rich colors, and close observation of detail. It evokes all the splendor, magnificence, and luxury of Venetian life. The composition is tripartite, with Christ seated at a table in the center with guests and servants. Under the arches at either side, animated diners are eating, talking, gesticulating, and moving around, with servants coming and going. The central space is

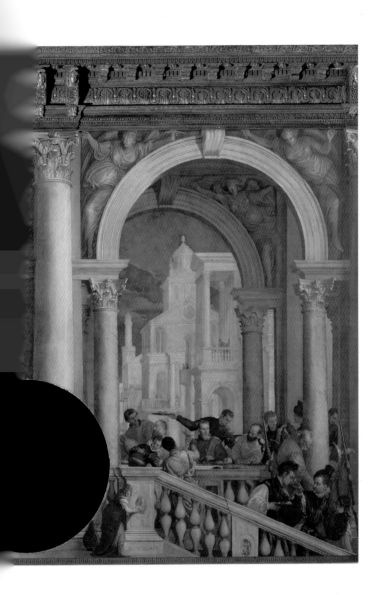

separated off by two large, attached Corinthian columns and, in front of each, stands a luxuriantly dressed man at the top of the steps leading down to left and right. These steps draw attention to the center and, since they resemble flights of steps leading to raised sanctuaries in Northern Italy, they imply that the center is a sanctuary and the table an altar. In the foreground is a jester, a dwarf, a monkey, and a dog. In the background, beyond the loggia, is a panoramic view of classical buildings.

Veronese used a wide range of colored pigments: orpiment, red lead, yellow *giallolino*, and lakes, as well as the earth colors. In addition, he used the finest pigments available in Venice at the time, such as ultramarine, malachite, verdigris, litbarge, realgar, vermilion, carbon black, and lead white.

In the background, the silvery tones of the architecture provide a backdrop against which the gorgeously clothed figures in their vibrant and brilliant colors are thrown into relief. The same color, but in a range of tones through to dark gray-blue, is used for the sky, along with a blush of pink, which is then applied to the nearer background buildings. This same pinkish color, but darker, is used for the architectural elements of the foreground. These three colors, steel blue, terracotta pink, and cream are also present in the geometric tiles in the foreground. Thus the composition is unified and depth is created. Against this muted setting, the amazing cacophony of color blazes.

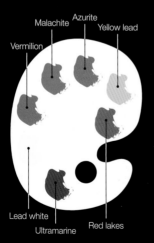

Malachite Azurite
Vermilion Yellow lead

Lead white
Ultramarine Red lakes

Veronese has an acute sense of the way that various materials reflect colors differently. These gorgeous greens are used to depict clearly the glorious sheen of this figure's brocade tunic, and the heavy mossy mass of his velvet cloak with its shimmering silk lining.

There are resonances here with Raphael's *School of Athens*. Classical architecture is used to provide a grand setting. The geometric pavement and perspective recession, as well as aerial perspective, provide a sense of depth and space. The main figures are placed centrally under the middle arch, while the banisters at either side emphasize the central group. Additionally, their orthogonals meet at a point above Christ's head. Illusionistic space is created as an extension to real space and, given the size of this painting, would create the impression that the viewer was directly observing the feast taking place at that moment. The gestures, poses, and interaction between the figures creates a sense of bustle and noise.

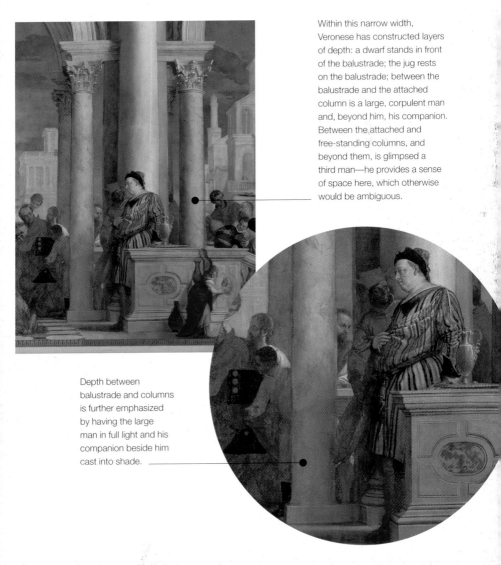

Within this narrow width, Veronese has constructed layers of depth: a dwarf stands in front of the balustrade; the jug rests on the balustrade; between the balustrade and the attached column is a large, corpulent man and, beyond him, his companion. Between the attached and free-standing columns, and beyond them, is glimpsed a third man—he provides a sense of space here, which otherwise would be ambiguous.

Depth between balustrade and columns is further emphasized by having the large man in full light and his companion beside him cast into shade.

Index